IMAGES
of America

VALDOSTA

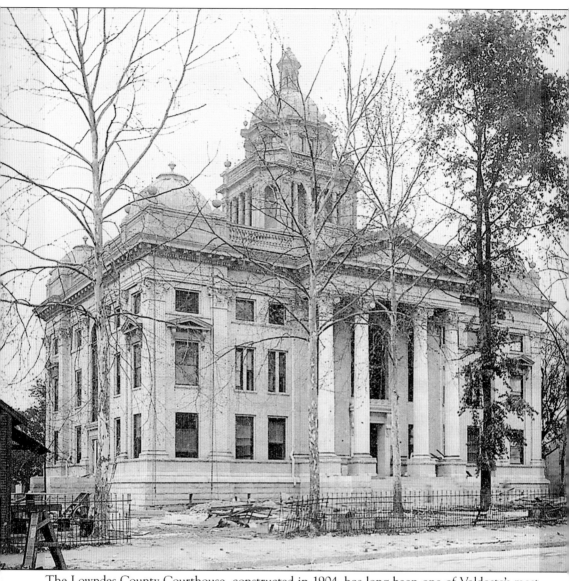

The Lowndes County Courthouse, constructed in 1904, has long been one of Valdosta's most recognizable landmarks. Its ornate dome has been a constant sight in a city that rapidly evolved around it. However, even this site has seen its share of change. Two other buildings occupied the space from 1860 to 1904. The first was a two-room, unfinished, wooden building and the second was a less ornate two-story brick structure. (Courtesy of Lowndes County Historical Society.)

ON THE COVER: In the early 1950s, the Valdosta Junior Chamber of Commerce sponsored nighttime street dances downtown. They were usually held in roped-off sections of Ashley and Patterson Streets. For this dance in 1953, however, organizers just roped off Patterson Street between Central and Hill Avenues. The streets of Valdosta have begun to come alive again in this manner with the recently introduced "First Friday" celebrations. (Courtesy of Lowndes County Historical Society.)

IMAGES
of America

VALDOSTA

Michael O. Holt

ARCADIA
PUBLISHING

Published by Arcadia Publishing
Charleston, South Carolina

Printed in the United States of America

Library of Congress Control Number: 2010938586

For all general information, please contact Arcadia Publishing:
Telephone 843-853-2070
Fax 843-853-0044
E-mail sales@arcadiapublishing.com
For customer service and orders:
Toll-Free 1-888-313-2665

Visit us on the Internet at www.arcadiapublishing.com

This book is dedicated to my wife, Miranda, and my daughter, Helen, who have both inspired me in all that I do.

CONTENTS

ACKNOWLEDGMENTS

In its 43-year history, the Lowndes County Historical Society has created an excellent museum and research archives that display important artifacts from the county's past and make thousands of images, documents, books, and periodicals on the region available to researchers. In addition, the Valdosta State University Archives provide another excellent resource for research about local history as well as a museum chronicling the history of the university. I am indebted to both organizations for granting me unrestricted access to their collections. Unless otherwise noted in the text, all of the images appear courtesy of the Lowndes County Historical Society. I would also like to extend my thanks to Myrna Ballard, president of the Valdosta–Lowndes County Chamber of Commerce, for permitting me to use pictures from the chamber's extensive image collection, which is archived at the historical society museum. I am also grateful to others who have granted me permission to use their images, including Peace Mission Church, Inc., Susan Davis, the *Valdosta Daily Times*, and the Valdosta Touchdown Club.

I would particularly like to thank Deborah Davis, archivist at the Valdosta State University (VSU) Archives, for encouraging and mentoring me in my efforts to assemble this pictorial history. I would also like to thank the staff of the Lowndes County Historical Society, including Donald O. Davis, for helping me in innumerable ways and answering all manners of my questions and pointing me towards valuable images I would not have otherwise thought to include. I am obliged to acknowledge the efforts of Brinkley Taliaferro, Georgia editor for Arcadia Publishing, for keeping me on course in making this book the best it could be. Above all, I thank Miranda and Helen for their love, support, and patience. Finally, I wish to extend a special thanks to my grandfather, the late Hubert Lee Scoggins. Without the stories he told me as a child about growing up in South Georgia, my interest in local history would have never flourished. This book would never have been possible without him.

INTRODUCTION

Valdosta is located in Lowndes County in the Wiregrass region of South Georgia, approximately 16 miles from the Georgia-Florida border. Americans originally settled the region in 1821, and Lowndes County was created out of Irwin County in 1825. Valdosta was not Lowndes's first county seat. The county's first seat was its first town, Franklinville, which was settled in 1827. Five years later, the county seat was moved to Lowndesville, situated at the confluence of the Little and Withlacoochee Rivers. The town was renamed Troupville in 1837 after the popular Georgia senator and former governor George Troup. Over the next several years, Troupville enjoyed a relatively prosperous existence and grew into a town of about 500 residents by the late 1850s.

In 1859, word arrived that a new railroad line from Savannah, the Atlantic and Gulf Railroad, was to run through Lowndes County, four miles to the east of Troupville. Though the decision was far from unanimous, the citizens of the town decided to move the county seat once again to meet the railroad. Troupville was uprooted as its citizens formed a new settlement along the railroad. On July 4, 1860, the first train rolled into the new town, which was incorporated on December 7 of the same year. The citizens named their new town Valdosta after George Troup's estate, Val d'Osta, which took its name from the Valle d'Aosta region in northern Italy.

Before Valdosta could truly be established, the Civil War broke out, and the town was literally put on hold. Though it was billed as a safe retreat from the ravages of war, in truth resources were quite scarce, and almost no shops were in business by the end of the war. Residents hoarded valuable supplies like sewing needles to patch worn clothes they could no longer replace. A number of Valdosta citizens fought and died for the Confederacy, including the town's first mayor, Reuben Roberds, and James Patterson, who had a major street named in his honor.

After the war, Valdosta struggled to grow during Reconstruction. Through the 1860s and early 1870s, the town made an earnest effort to adjust to the changing times. The Valdosta Institute was established as the city's first official school in 1865 to educate the youth of the community. The town's first newspaper, the *South Georgia Times*, was established in 1868 specifically to aid residents in making the necessary adjustments to help the region flourish. Most of the acreage went back to the farming of Sea Island cotton, which soon got the town moving again.

In the late 1870s and early 1880s, Valdosta became a major inland market for Sea Island cotton, becoming the largest inland market in the world by 1900. As a result of the cotton boom, two related industries—cottonseed oil and fertilizer—also prospered in Valdosta. During this time, the city took on a much more elegant appearance as large Victorian homes, ornate storefronts, and popular hotels the Stuart and the Florence appeared. The Methodist and Baptist churches both built elaborate meetinghouses in the 1890s that are still prominent downtown landmarks. By the end of the 1800s, Valdostans were so proud of their community that they hosted two successive state fairs in 1899 and 1900 to dress up and show off the town.

Valdosta continued to grow in the early years of the 20th century. A street railway was constructed in 1899 but truly flourished in the 1900s and 1910s. The luxurious Patterson and Valdes Hotels

were built in the first 15 years of the new century. A new domed courthouse came into existence in 1904, and a post office and federal building opened its doors in 1910. An extremely important event in Valdosta's history occurred in 1913, when South Georgia State Normal College, which developed into Valdosta State University, welcomed its first students. The city school system also started in this era as the town continued to relish the boom years of the cotton trade.

The boom was cut short in the late 1910s, when boll weevil infestation decimated the cotton trade. The 1920s and 1930s brought tough economic times to the region, but Valdosta continued to grow. The rich tradition of high school football in the region also began to flourish during these years. Though the town eventually recovered, true prosperity did not return to the region until the outbreak of World War II. It was during this time that Moody Field was established. This Air Force base has grown substantially in recent years and is one of the primary economic engines in the region.

The long period of slow growth and hard times in Valdosta meant that a lot of basic upkeep on the city's homes and buildings was neglected. As a result, a number of the town's historic structures fell to the wrecking ball in the 1950s and 1960s to make way for future development. A major factor in economic growth during this era was the opening of Interstate 75, which ran slightly west of the old Valdosta downtown. The region's sports reputation continued to grow during this era; the Valdosta High School Wildcats were selected as national football champions in 1969 and 1971.

During the 1960s and 1970s, the downtown region declined greatly as the city spread outward. The decline continued until the construction of the James Beck Overpass resulted in the demolition of the old Atlantic Coast Line Railroad passenger depot in 1982. The following year, the city received special status and funding to preserve its historic downtown, which has brought new life to the region.

Currently, Valdosta has a population of nearly 45,000 people. In recent years, a number of businesses have moved into long vacant downtown buildings. In addition, the town has begun to hold "First Friday" celebrations to draw people back to the downtown area. In 2008, ESPN named the city TitleTown USA as homage to its rich and storied sports history. Valdosta has grown exponentially since it started as a stop on a rail line in 1860; it celebrated its sesquicentennial in December 2010.

One

1860–1899

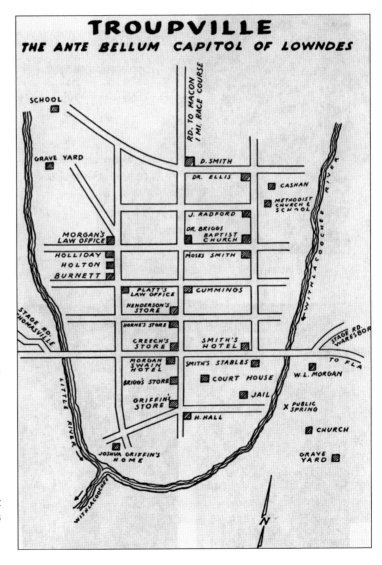

TROUPVILLE
THE ANTE BELLUM CAPITOL OF LOWNDES

SCHOOL

RD. TO MACON
1 MI. RACE COURSE

GRAVE YARD

D. SMITH

DR. ELLIS

CASHAN

METHODIST
CHURCH &
SCHOOL

J. RADFORD

MORGAN'S
LAW OFFICE

DR. BRIGGS
BAPTIST
CHURCH

HOLLIDAY
HOLTON
BURNETT

MOSES SMITH

PLATT'S
LAW OFFICE

CUMMINGS

HENDERSON'S
STORE

STAGE RD.
TO THOMASVILLE

HORNE'S STORE

CREECH'S
STORE

SMITH'S
HOTEL

STAGE RD.
TO WARESBOR

MORGAN
SWAIN
HOTEL

SMITH'S STABLES

TO FLA

BRIGG'S STORE

COURT HOUSE

W. L. MORGAN

GRIFFIN'S
STORE

JAIL

PUBLIC
SPRING

H. HALL

CHURCH

LITTLE RIVER

JOSHUA GRIFFIN'S
HOME

GRAVE
YARD

WITHLACOOCHEE RIVER

WITHLACOOCHEE RIVER

N

In 1859, the county seat was located at Troupville, a town of about 500 at the confluence of the Little and Withlacoochee Rivers. When the county received word that a new railroad was coming through the county four miles from Troupville, the decision was made to relocate the county seat to the rail line. Citizens named the town they established Valdosta.

The Wisenbaker family, shown here around 1861, was not pleased to learn that a railroad would soon cut through the family farm. The Wisenbakers sold 140 acres to the county so it could build a new county seat along the rail line. The family then moved a few miles south to join other members of the family in the small town of Dasher.

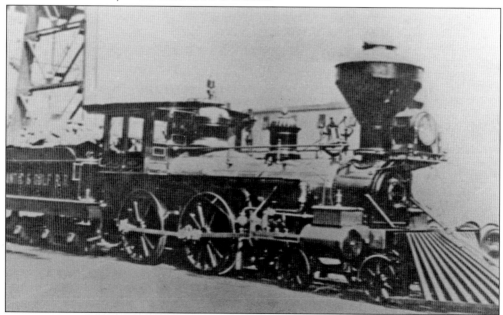

The Satilla No. 3 was the first train to arrive in Valdosta on the newly completed Atlantic and Gulf Railroad in July 1860. The arrival was publicized weeks in advance, and a large barbecue dinner was planned. At the time, most of the residents of Lowndes County had never seen a steam engine. Many of them gathered more out of curiosity than to celebrate the linking of the area with Savannah.

In December 1860, 26-year-old Reuben Thomason "Tompy" Roberds was elected the first mayor of Valdosta. He did not serve for long, as he was among the first to sign up for military service when the Civil War began. Roberds was appointed sergeant in the Valdosta Guard (Company D, 50th Georgia Volunteer Regiment), where he rose in rank to major before losing his life at Knoxville in 1863.

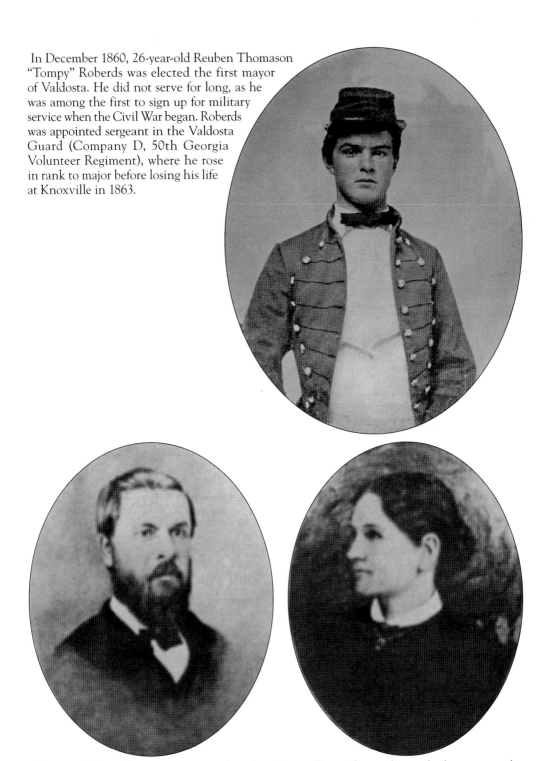

Albert and Mary Converse were two longtime Troupville residents who made the move to the new city of Valdosta. Their son Albert Converse Jr. was the first baby to be born there. The home Albert Jr. constructed on North Patterson Street still stands today, though its once spacious yards have been replaced with businesses that nearly touch the house.

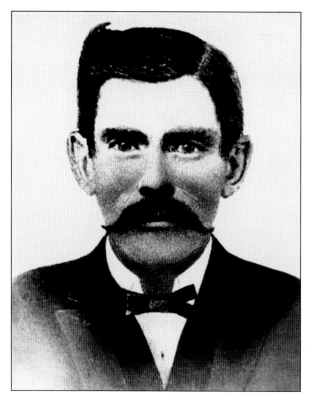

The famous western gunfighter Doc Holliday, known for his involvement in the O.K. Corral shootout, came to Valdosta with his family in 1864. During the years when Holliday lived in Valdosta, he showed no signs of the life he came to lead in the West. He primarily spent his days at the Valdosta Institute, where he received a classical secondary education that prepared him to attend dental school in 1870.

James Lord Pierpont, who composed the holiday classic "Jingle Bells," was a resident of Valdosta in the late 1860s. He taught music and made a number of friends in the community. His youngest son, Maynard Boardman Pierpont, was born in the city. In 1869, the family moved on to Quitman in neighboring Brooks County where Pierpont played the pipe organ for the Presbyterian church.

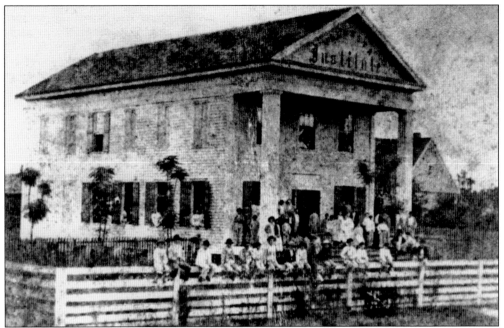

In 1865, S.M. Varnedoe was invited to Valdosta to open a school. He purchased a building known as Mason Hall and converted it into a school that was called the Valdosta Institute. This photograph shows the original wood-frame institute as it was in the late 1860s, before Varnedoe added two wings to the structure to accommodate the increasing student body.

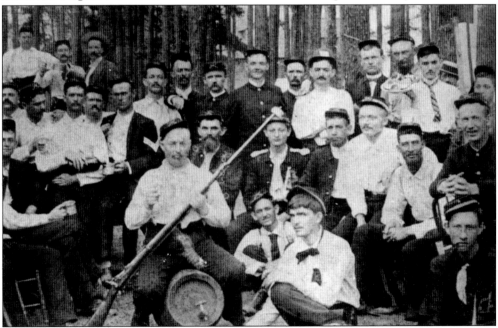

In the summer of 1865, a garrison of Federal troops established its headquarters in the county courthouse. These soldiers were under the command of Gen. Q.A. Gillmore, who had stationed units along the Atlantic and Gulf Railroad from Doctortown to Thomasville. Company G of the 103rd Infantry, US Colored Troops, replaced these men by the end of the year.

Maj. Philip C. Pendleton wanted to publish a newspaper to help people adjust to the changes in the region. He bought out the defunct paper of Troupville, the *South Georgia Watchman*, and began publication of the *South Georgia Times* on March 20, 1867. Pendleton died in an accident in 1869, but the paper he founded continued and is still published today as the *Valdosta Daily Times*.

Abraham Ehrlich was one of the first Jewish residents of Valdosta. He came to America in the mid-1850s and worked as a peddler with his uncle George Ehrlich. He fought for the Confederacy during the Civil War and was seriously wounded at Chickamauga. After the war, he met Benjamin Kaul, another early Jewish resident, and the two opened a general store on Patterson Street.

In 1871 and 1872, approximately 112 African American citizens of Lowndes County immigrated to Liberia with the support of the American Colonization Society. At the age of 14, Laura Yerby, pictured here in the 1890s, went with the first group of 63 immigrants in November 1871. Unfortunately, many of the former slaves did not fare well, and currently, less than five percent of Liberia's population is descended from former slaves.

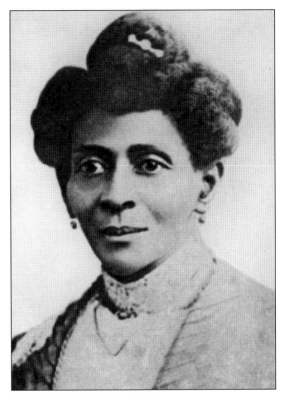

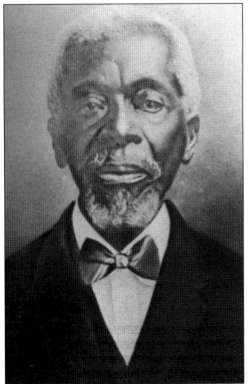

In 1865, eighteen freedmen founded the Macedonia Baptist Church, one of the oldest churches in Valdosta. The congregation's spiritual leader was 52-year-old Charles Anderson, who was born a slave in Savannah in 1813 and became known for leading worship services for other slaves after he came to Valdosta.

These images show two views of the oldest surviving house in Valdosta. The home was originally built by William Wisenbaker in 1840. The picture above shows the home as it appeared in an 1885 panoramic lithograph of Valdosta. At this point, the house had still not received the distinctive Victorian architectural features for which it remains well known, though it had grown in size from the original structure that Wisenbaker built. In 1893, John T. Roberts acquired the house and added Victorian gingerbread wings and towers to the original structure. The image below, taken after a rare snowfall in Valdosta, shows the home as it appeared in the 1890s.

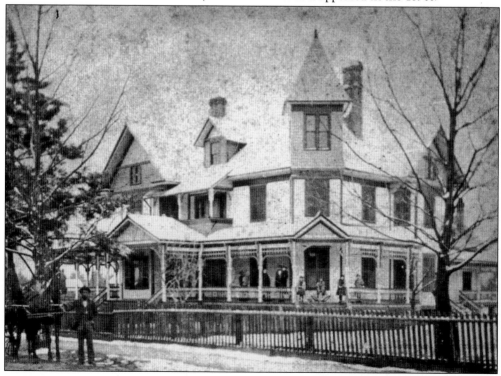

In 1884, Joe H. Stump opened a sign painting business on Hill Avenue. By 1887, it had transformed into a paint and building materials enterprise that was sold to C.H. Paine and C.B. Peeples. It was repurchased again in 1912 by Robert Stump and Turner Rockwell. This photograph shows the business as it appeared in 1884, shortly after it was established by Stump.

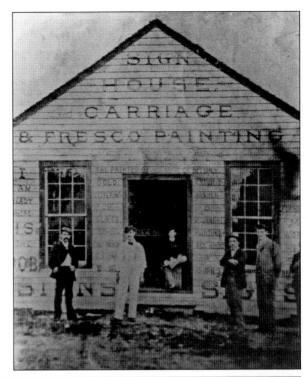

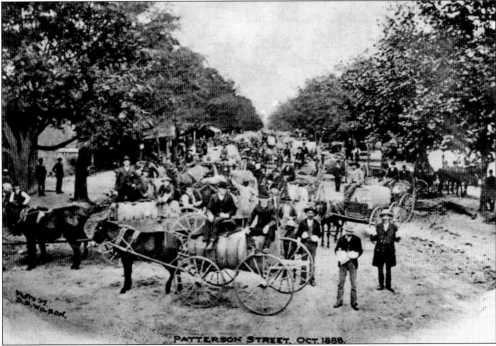

Valdosta's economy had slowed to a crawl in the aftermath of the Civil War, but the reemerging market for Sea Island cotton helped the town transform into a booming market town for the crop. This photograph shows a large crowd of cotton merchants on Patterson Street in 1885. By this time, production of Sea Island cotton in the surrounding region had nearly doubled from 1866.

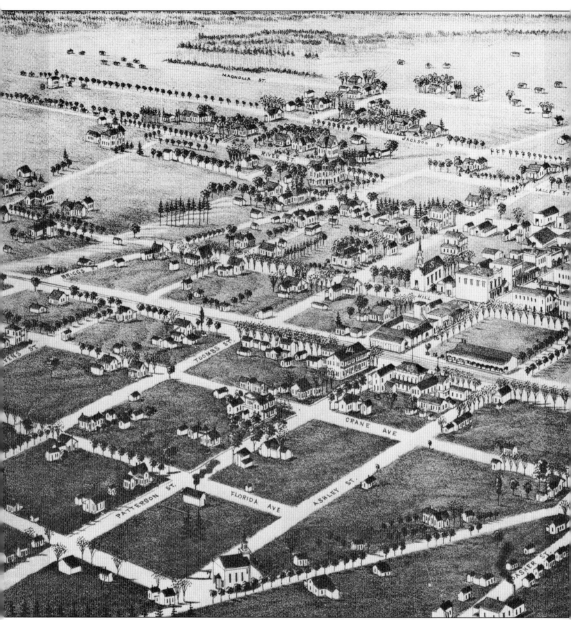

This lithograph shows a panoramic view of Valdosta as it appeared in 1885. The town had grown significantly since it was established in 1860, and the postwar recovery is evident in this image. By this time, the town boasted two major hotels, the Prescott and the Stuart (which burned shortly before this map was completed), seven churches, a number of merchants, an opera house, and a

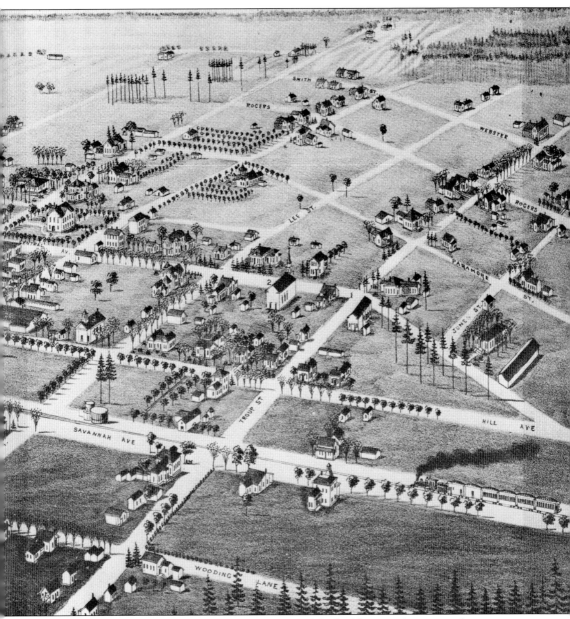

Image labels visible on map: ROGERS, SMITH ST, WEBSTER, ROGERS, LEE ST, PARAMORE, ST, JONES ST, AVE, TROUP ST, SAVANNAH AVE, HILL AVE, WOODING LANE

brick courthouse constructed in 1875. However, most of the buildings in this map no longer exist. Two notable structures that remain in 2010 are on Patterson Street: the Wisenbaker Building, on the corner of Patterson Street and Hill Avenue, and the Briggs-Smith Building, on Patterson Street just south of Benny's Alley.

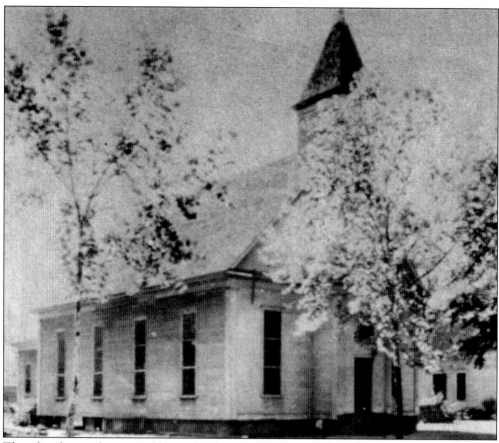

This church was the original home for the Missionary Baptist congregation that moved from Troupville to Valdosta. In 1899, the newly formed Valdosta Primitive Baptist Church purchased the building and became the only Primitive Baptist meetinghouse with a steeple in South Georgia. After the Primitive Baptists moved out, the building became home to a Pentecostal congregation that remains there today.

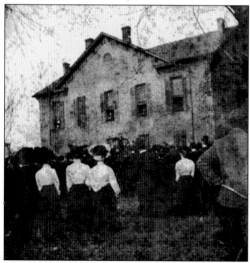

The original Lowndes County Courthouse in Valdosta was an unfinished, two-room wooden building located on the southeast corner of Ashley Street and Central Avenue. In 1875, a brick courthouse was erected on the square in Valdosta. This building stood until 1904, when the present courthouse was constructed in the same location.

In 1885, six prominent Valdosta citizens pooled their money to purchase the Valdosta Institute and the land on which it resided. They then gave the property to the city with the understanding that a new brick building would be erected. After the new structure was completed, the school was placed under a board of trustees and managed as such until the public school system was established in 1893.

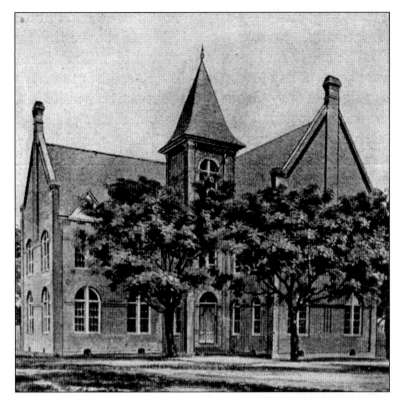

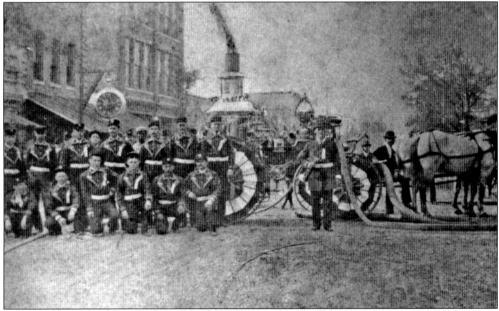

After two destructive fires swept through Patterson Street in 1869 and 1870, the city organized a volunteer patrol company in 1871. The volunteer patrol became the Patterson Fire Company in 1872. The unit was outfitted with a hand-pump engine and uniforms consisting of a red flannel shirt, black trousers, and a black hat. An African American fire company called the Osceola Hook and Ladder Company was formed soon after.

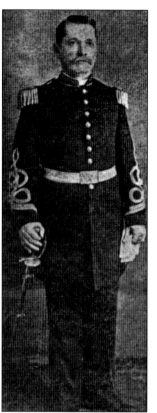

In 1887, a volunteer military company was organized by J.O. Varnedoe (pictured in his dress uniform) in the offices of the *Valdosta Daily Times* on Patterson Street. Officially named Company B, 4th Infantry, Georgia State Troopers, this company was called the Valdosta Videttes. It consisted of about 40 members. Each purchased his own uniform and received a .45 caliber rifle from the state. Until their armory was completed, Varnedoe drilled his men on the city square, which ran from Valdosta City Hall to Lee Street (pictured below). By the early 1900s, new laws concerning the organization of militias began to make the Videttes obsolete, and by 1912, the company had disbanded, leaving Lowndes County with no state or national militia organization until 1924.

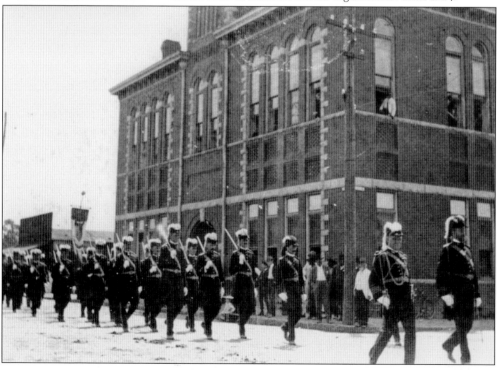

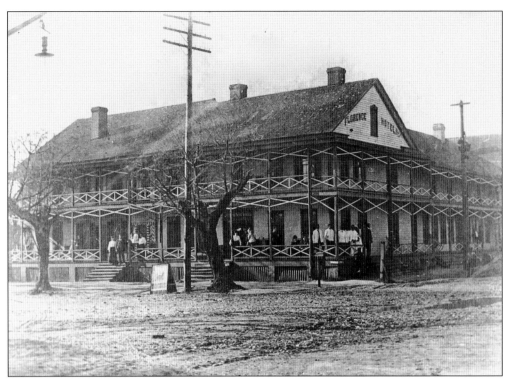

The Florence Hotel, formerly known as the Prescott House, was a popular lodging just off the Atlantic Coast Line Railroad on South Patterson Street. The wooden, two-story hotel was a prominent destination in town, but by the end of the 1800s, it showed its age. The building was torn down and replaced by the Patterson Hotel in 1912.

This picture shows the offices of the First National Bank of Valdosta in 1899. The building the bank occupied is one of the oldest surviving structures in Valdosta. It was constructed some time prior to 1885, when it appeared on the Sanborn Fire Insurance Maps as a general store with offices and a printing press on the second floor. The Victorian cornices on the building were removed in the early 1900s, but the window flourishes remain.

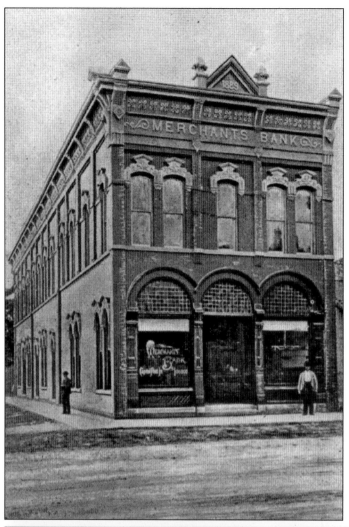

Remer Y. Lane had conducted a private banking business for some time when he and his associates chartered what became the Merchants Bank of Valdosta in 1888, the first bank organized with a state charter in southwest Georgia. The bank was located on South Patterson Street and became the Citizens and Southern National Bank in 1926. Today, it is a Bank of America, though it has occupied two other buildings on the same location. The image below shows the original board members of the bank. From left to right are H.Y. Tillman, E.P.S. Denmark, Mills B. Lane, R.Y. Lane (president), W.R. Strickland, Lowndes W. Shaw, Frank Strickland, and unidentified.

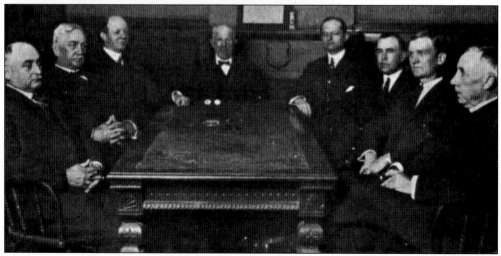

In 1893, Mayor William H. Griffin approved the plans for a new city hall, which was constructed on the corner of Hill and Ashley Streets. The building was completed on May 11, 1895, and was elaborately decorated with architectural features of the popular Second Empire and Beaux-Arts styles. The structure also contained a large assembly hall that was designed for city council meetings and other public gatherings.

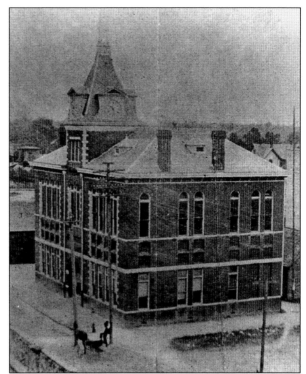

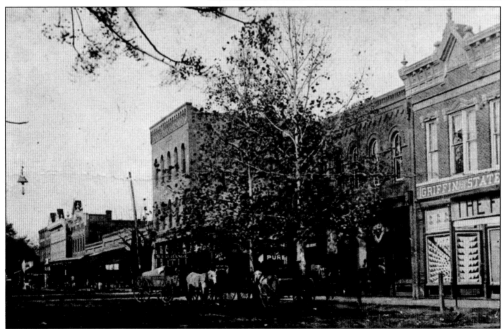

This photograph of Patterson Street, taken around 1890, shows a downtown view that quickly changed in the coming decades. However, at least two structures in this image still stand today. The three-story building in the middle of the picture is the Kress Building, and the structure that is third from the left is the Briggs-Smith Building, which is one of the oldest surviving structures in downtown Valdosta.

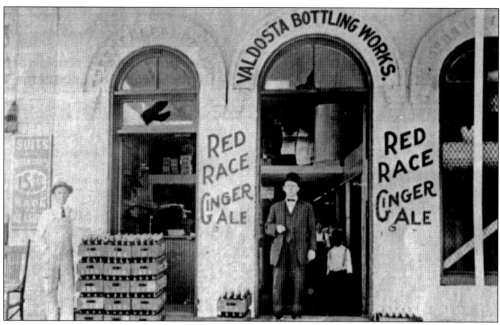

In 1897, E.R. Barber (pictured in doorway) moved to Valdosta and purchased shares in a bottling company that he co-owned with J.F. Holmes. They were Valdosta's pioneer bottlers and bottled a number of soft drink brands. They were well known at the time for Red Race Ginger Ale but they are also remembered as being the second facility ever to bottle Coca-Cola.

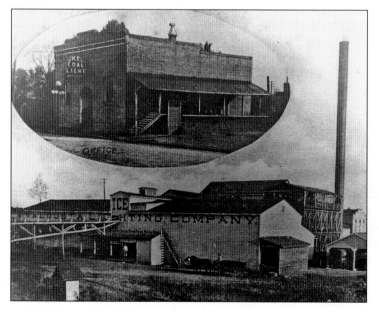

The city's first electric service provider, the Valdosta Ice and Lighting Company, was established in 1890. This image shows the company's offices and ice and power plant. Soon after its founding, the company's electric service was taken over by the Georgia Power and Light Company. The ice business changed hands several times before it was purchased by the Atlantic Ice and Coal Company of Atlanta in 1938.

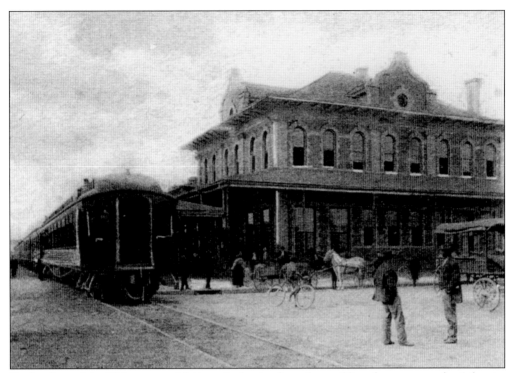

By the close of the 19th century, Valdosta had gained another rail line downtown—the Atlantic, Valdosta, and Western Railway (AV&W), which operated a line that ran from Valdosta to Jacksonville. This photograph shows the AV&W's passenger depot, located at the corner of South Patterson Street and Florida Avenue. The Georgia Southern and Florida Railway purchased the line in 1902.

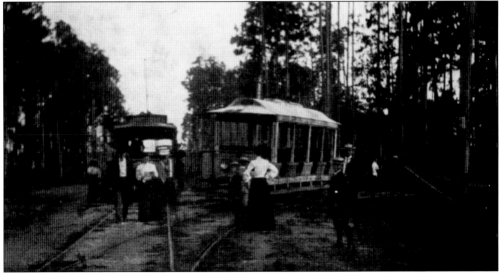

In 1899, a street railway was established in the city and ran from downtown Valdosta to Pine Park. The line was originally established to provide citizens a ride to the state fairs at Pine Park in 1899 and 1900. This image shows passengers and streetcars at the intersection of Patterson Street and Alden Avenue soon after the railway was constructed.

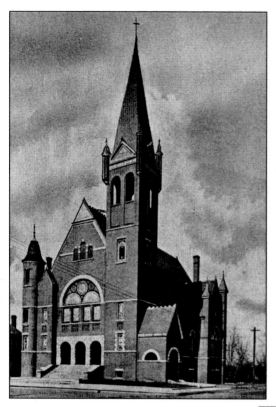

During the last half of the 1890s, two of Valdosta's most recognizable churches were built downtown. The first to be completed was the First Baptist Church (at left) in 1895. The building originally had a brick facade, though it was painted over in the 1960s. Three years later, the First Methodist Church (below) opened its doors, and its appearance has stayed largely the same since the day it opened. Though other historic churches in the downtown area have been demolished and relocated, these two churches still remain with large and active congregations.

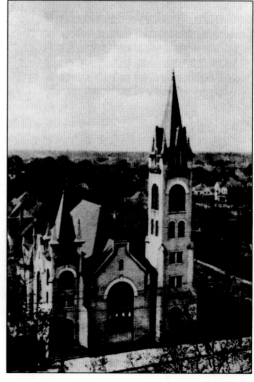

Two

1900–1919

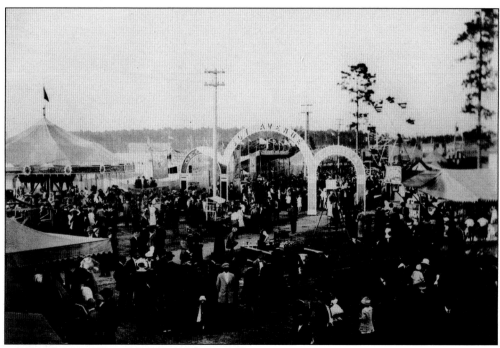

In 1900, Valdosta hosted the first state fair held in South Georgia. One Valdostan remarked that the town did its best to "spruce the whole place up in its Sunday bests." The newly constructed fairgrounds boasted a number of attractions for the thousands who flocked to Valdosta for the weeklong affair. This image shows the entrance to the midway at the fairgrounds, which came to be known as Joy Avenue.

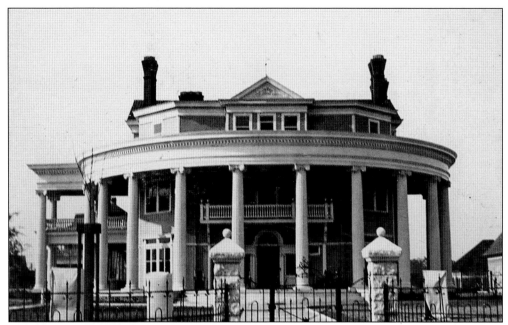

This image shows one of Valdosta's most famous homes, the Crescent, shortly after its completion. Col. William S. West, a prominent Valdosta resident who had served in the state assembly, built the house in 1898. The residence was a reflection of West's prosperity and was the first home in Valdosta to feature electric lights, indoor plumbing, and central heating.

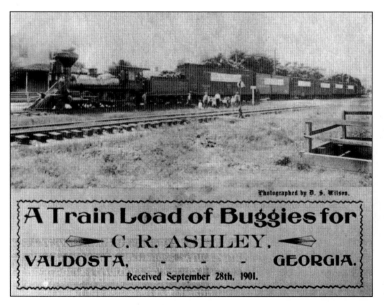

This image of a trainload of buggies being delivered to a Valdosta business in 1901 is illustrative of the ever-changing nature of transportation in the town. The train—the lifeblood of the city—was bringing buggies. However, the automobile soon replaced buggies and eventually eliminated the need for passenger service in Valdosta.

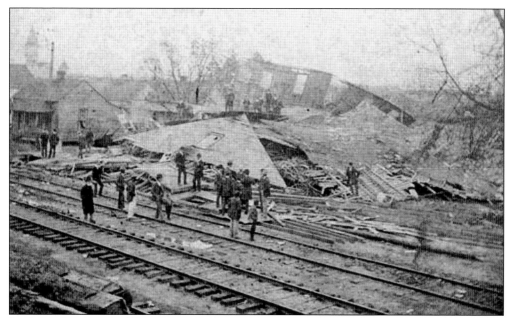

In the early 1900s, Valdosta was a major producer of buggies and boasted three factories that manufactured them. One of these businesses was completely destroyed when a tornado blew through downtown Valdosta in 1904. This image shows residents examining the remains of the buggy factory after the storm.

This photograph shows the Valdosta City School system as it existed in the early 1900s. The building on the left is the former Valdosta Institute, which served as a grammar school and later as a junior high school. The structure on the right was completed in 1905 and was the original Valdosta High School. It was replaced by a new facility on Williams Street in 1921.

This image provides a panoramic view of the bustling world surrounding the Atlantic Coast Line Railroad passenger depot in the early 1900s. Throughout the scene, several modes of transportation, including buggies, bikes, and horses, are visible. The large number of people in the business district of the city is indicative of the prosperity that was brought from the Sea Island cotton boom. The passenger depot was located between Ashley and Patterson Streets and faced the tracks on

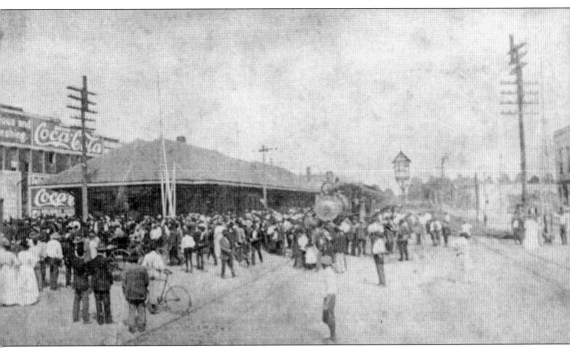

Savannah Avenue. It was torn down when the James Beck Overpass was constructed, but most of the buildings on Patterson Street immediately behind the depot remain today. The structure on the other side of the street was part of a block of buildings that was torn down where the main Valdosta branch of Bank of America stands today.

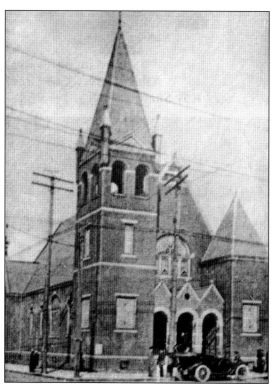

The First Christian Church was constructed on Hill Avenue in 1903 to replace the wooden building that burned down in 1901. This structure served the congregation until 1956, when it moved to a new church at the corner of North Patterson Street and Alden Avenue. After the move, the Hill Avenue church was demolished.

Crown Bottling Company was started when J.L. Harris purchased Brantley Bottling Works from J.F. Holmes and E.R. Barber. Harris and his partner, S.A. Chitty, began their bottling business with a single horse and wagon but were operating four trucks by 1940, when they bottled Royal Crown Cola and NeHi beverages.

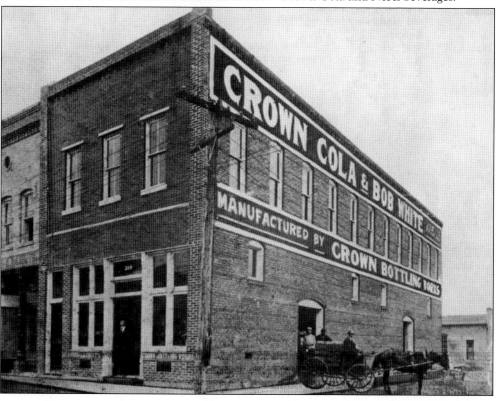

Strickland Cotton Mill was organized in 1899 and was one of the most prosperous enterprises in Lowndes County soon after it opened its doors in 1900. The plant was located about three miles outside of Valdosta, and a small village named Remerton grew around it for the factory workers. As Valdosta grew, it slowly surrounded the village, which still exists an independent city today.

This image shows a group of Valdostans trap shooting on North Patterson Street in 1904. The area where they are shooting is near the corner of North Patterson and College Streets, where Christ Episcopal Church stands today. This was close to the city fairground, which was located between Patterson and Williams Streets from Moore Street to Park Avenue.

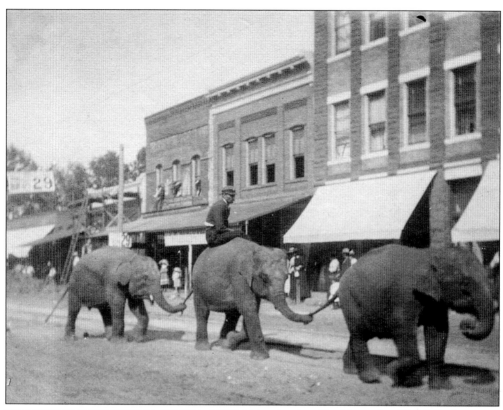

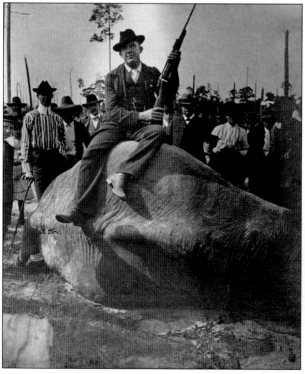

On November 22, 1902, the Harris Nickel Plate Circus finished unloading its train cars in Valdosta and was parading north to the fairgrounds, much like the image above. James O'Rourke, the trainer for the show's prize elephant Gypsy, fell off the animal and was crushed to death near First Baptist Church. The elephant went on a rampage that lasted all night and terrorized all of Valdosta, including guests at the newly opened Valdes Hotel, where Gypsy had been cornered early in the pursuit. Gypsy was finally killed by a high-powered Krag-Jorgensen rifle that had to be brought in from Clyattville. After people posed for pictures with the dead elephant (left), it was buried where it fell near Cherry Creek. The same day, O'Rourke's body was buried in Sunset Hill Cemetery.

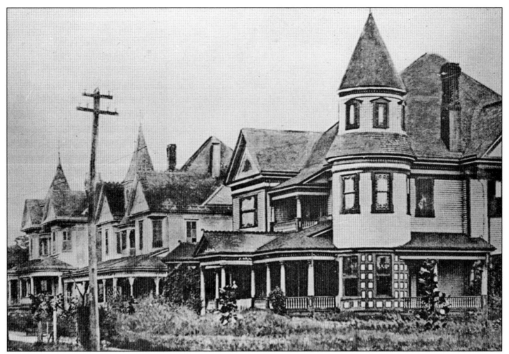

This image shows a row of houses on North Patterson Street in 1906. The large Victorian structures afforded room for large families. As upkeep and repair became more expensive, most of Valdosta's more ornate residences, including all of the homes in this picture, fell into disrepair and were eventually demolished.

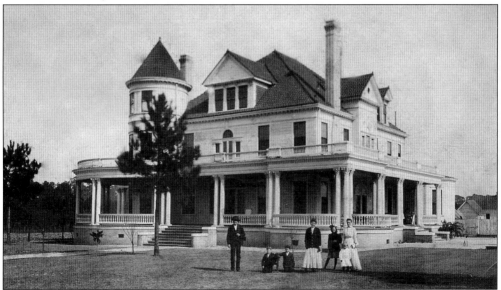

The house in this image was the residence of John N. Bray, vice president of the A.S. Pendleton Company and owner of the J.N. Bray Lumber Company. The home was located at 1203 North Patterson Street, near the intersection with Ann Street. The Brays moved out of the home, but it remained occupied until it was demolished in the mid-1960s to make room for the Brookwood Shopping Plaza.

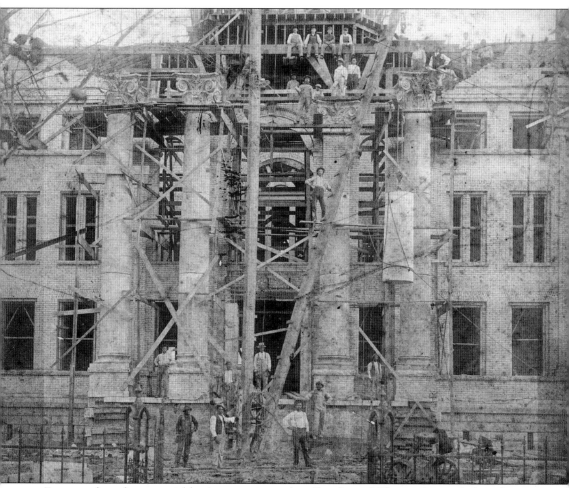

For a number of years, neighboring counties such as Brooks and Thomas boasted of much nicer courthouse facilities than Lowndes County, which had the most populous and prosperous county seat in the area. In 1904, the city and the county set out to change that and began to build a more ornate county courthouse. This image shows the construction process. At this stage, the four pillars in the front of the courthouse were being erected. Workers in the photograph were each paid a wage of 60¢ per day. Construction was completed in 1905, and the building has been in continuous use since then. The county courthouse is perhaps the most recognizable landmark in the city and is one of the images most often associated with Valdosta. In 2010, the courthouse's judicial services moved out of the 95-year-old building to a new facility on Ashley Street.

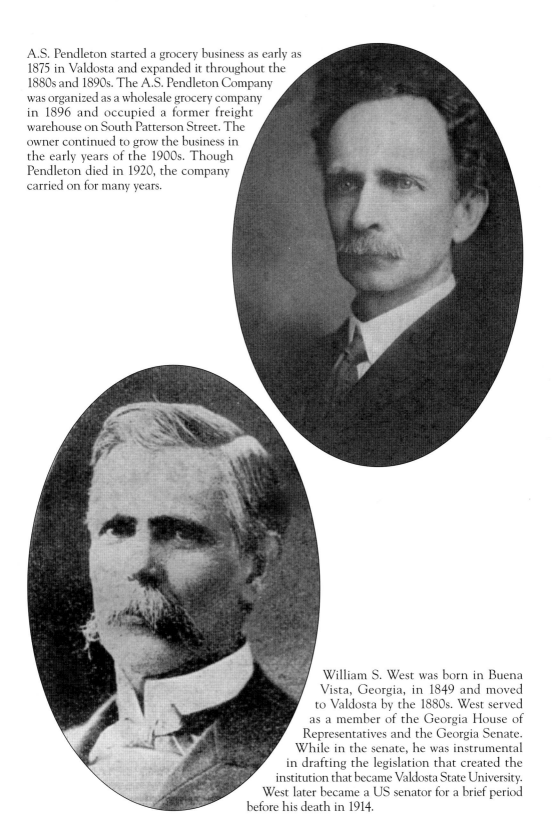

A.S. Pendleton started a grocery business as early as 1875 in Valdosta and expanded it throughout the 1880s and 1890s. The A.S. Pendleton Company was organized as a wholesale grocery company in 1896 and occupied a former freight warehouse on South Patterson Street. The owner continued to grow the business in the early years of the 1900s. Though Pendleton died in 1920, the company carried on for many years.

William S. West was born in Buena Vista, Georgia, in 1849 and moved to Valdosta by the 1880s. West served as a member of the Georgia House of Representatives and the Georgia Senate. While in the senate, he was instrumental in drafting the legislation that created the institution that became Valdosta State University. West later became a US senator for a brief period before his death in 1914.

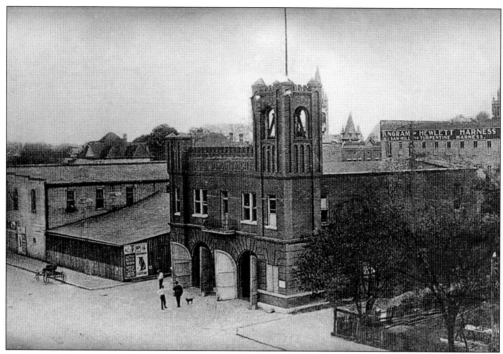

A home for the city's newly created paid fire department was opened in 1905. The station originally housed mule and jersey wagons, though mechanized wagons were soon added. The station also featured a modern fire alarm system with 15 street stations. A bell atop the station chimed the number of triggered alarm stations to let the fireman know the location of the fire.

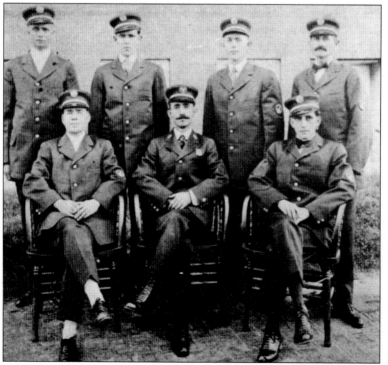

This image of the 1916 members of the Valdosta Fire Department shows three long-serving firemen. Tom Cook, seated in the center, served under the original chief, L.C. Varnedoe, before being elected chief in 1916, a position he held for more than 30 years. R.A. Black, standing farthest left, and Harry Ulmer, standing next to Black, both served for more than 30 years in the department as well.

John T. Roberts was mayor of Valdosta from 1906 to 1916. He had an active civic life as a member of the city council before he was elected as mayor. Roberts ran a store with T.G. Cranford and J. Alex Dasher on Hill Avenue that was a popular source for buggy equipment and farm implements. He lived on Wells Street in what is now the oldest house in Valdosta.

This image shows the J.T. Roberts Building around 1903. It was constructed around 1895 and served as the home of Roberts's business until 1911. It was subsequently occupied by Barnes Drug Store and a number of other tenants until the mid-1960s, then it was left vacant until 2006, when it was purchased by preservation-minded investors who performed an extensive and historically sensitive renovation over a two-year period.

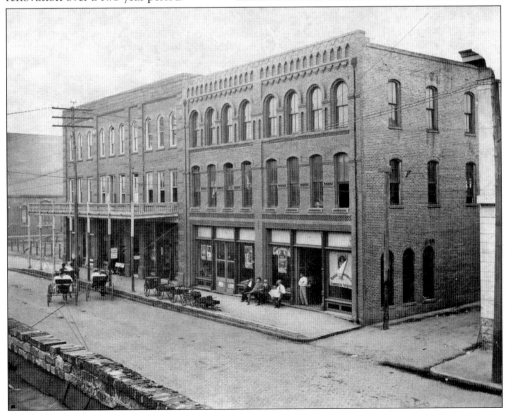

This image shows a procession called the "Pride of Valdosta" on display in front of the recently constructed Valdosta High School on an unpaved Central Avenue in 1906. The well-appointed display showcased the most beautiful girls, the most handsome men, and the finest horses the town had to offer.

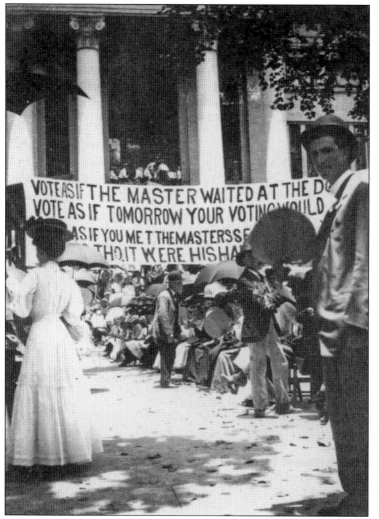

In 1907, a Prohibition movement led by Baptist minister Luther Rice Christie swept through Lowndes County. This image shows the crowd gathered for a county Prohibition referendum. Voters had to make their way through the crowd of Prohibition supporters to cast a ballot. After the votes had been counted, Lowndes had chosen decisively for Prohibition.

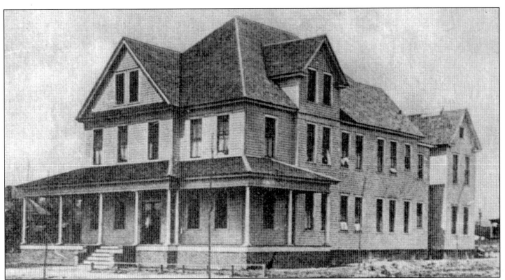

The structure in this image was originally built in 1908 as the Union Hospital, with Lizzie Mitchell serving as matron. By 1912, the building was repurposed as the Adair Street School, which lasted until 1936. The edifice was later acquired by St. John's Catholic Church and used as an educational building until it was torn down in the early 1970s.

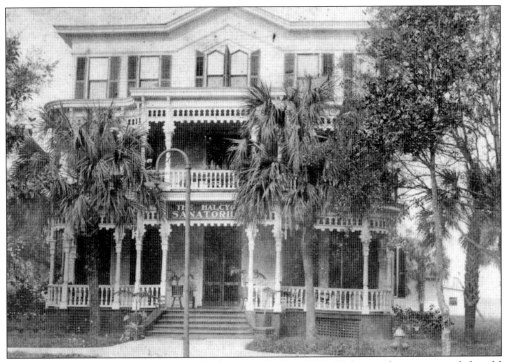

The Halcyon Sanatorium was established in 1906 by Dr. J.B.S. Holmes, who repurposed the old W.B. Johnson residence at the corner of Troup and Rogers Streets for medical use. It was the second hospital established in the city, and a number of doctors practiced there. The name briefly changed to the Bellevue Sanatorium, but by the mid-1920s, the facility was no longer in use.

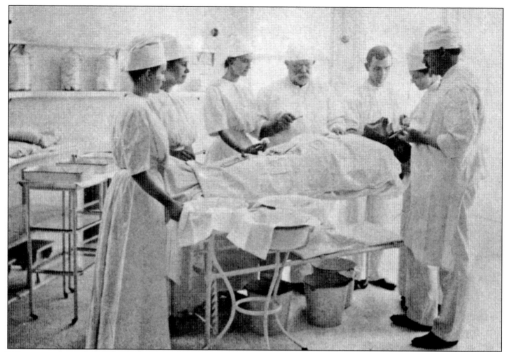

This picture shows the operating room of the Halcyon Sanatorium, which was said to be quite advanced for the time. A number of prominent Valdosta doctors are in this image. Fourth from the left is Dr. J.B.S. Holmes, founder of the Halcyon Sanatorium; Dr. Frank W. Thomas, who practiced medicine in Valdosta until he was 90, is third from the right; and Dr. A.G. Little, who cofounded the Little Griffin Hospital in 1915, is at the far right.

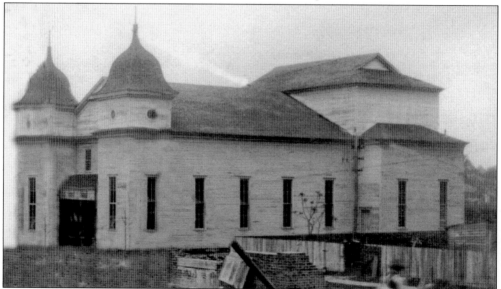

Shown here is Valdosta's original opera house around 1909, after work had begun on the post office. Soon after, the facility was purchased by the Lee Street Baptist Church, which made renovations to the building as the congregation grew. The original wood structure eventually gave way to a stone building, which the church later left for another facility.

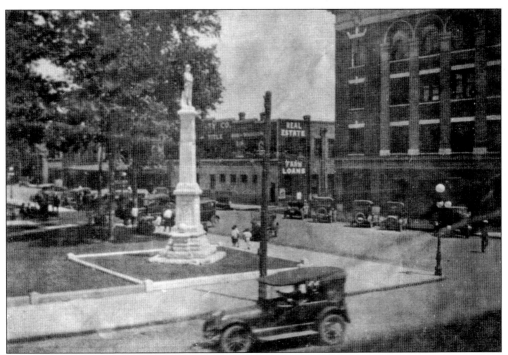

The Confederate Memorial, which sits on Courthouse Square at the corner of Central Avenue and Patterson Street, was unveiled on October 20, 1911, by R.A. Peeples, president of the local chapter of the United Daughters of the Confederacy. Maj. J.O. Varnedoe, a Civil War veteran and Valdosta resident, provided a speech for the occasion.

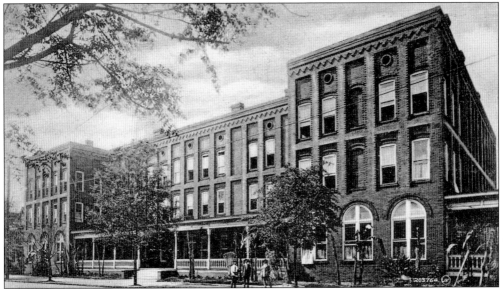

On September 1, 1902, the Valdes Hotel opened to the public. The hotel's name was a combination of Valdosta and Lowndes. It was located on the corner of Hill Avenue and Toombs Street. The lodging was expanded soon after it opened with a large wing on Toombs Street. The Valdes was celebrated in the region for its restaurant, which featured the cooking of four African American chefs from Alabama.

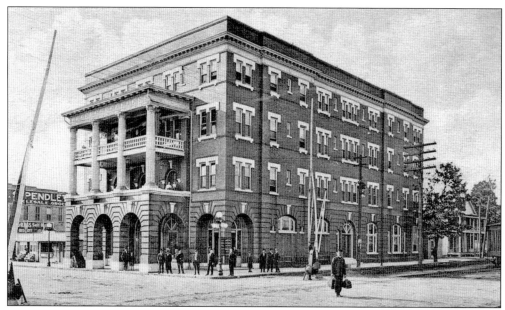

The Patterson Hotel opened on the site of the Florence Hotel in 1912 and was a prominent Valdosta landmark for nearly 50 years. The building was well appointed, and a number of important meetings, including a dinner celebrating the opening of South Georgia State Normal College (Valdosta State University), were held there. The hotel was a casualty of the interstate's diversion of traffic. It was demolished shortly before 1960.

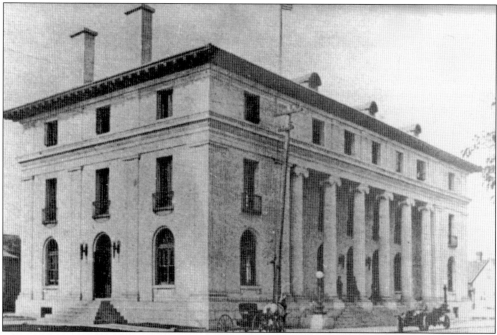

From 1910 to 1969, this structure was the Valdosta Post Office and federal building. It is pictured here shortly after it was finished in 1910. In 1970, it became the third Valdosta City Hall and remains so today. In May 2010, the building celebrated its 100th anniversary with a ceremony and a plaque that tells the story of its long history.

Shown here is the interior of the Valdosta Post Office and federal building during construction. The building took nearly two years to complete. Its intricate details in the Italian Renaissance Revival architectural style are clearly on display in this picture. Noticeably absent at this stage of the construction is any sign of electrical wiring.

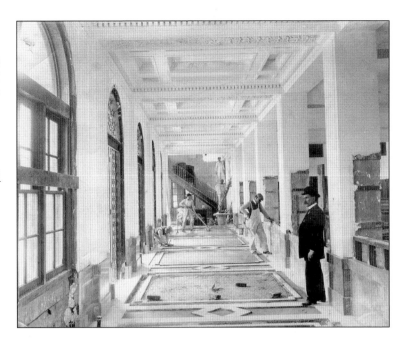

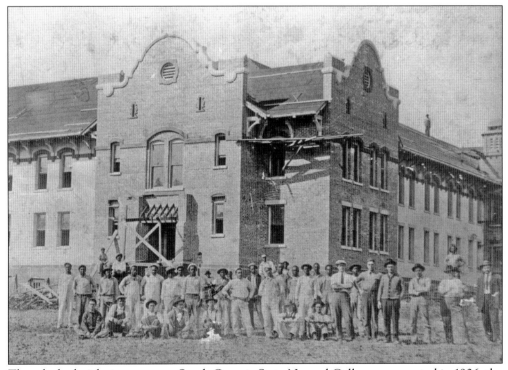

Though the legislation to create South Georgia State Normal College was enacted in 1906, the construction of the first building did not begin for several years. This image shows Building One during its construction in 1912. The building was later named Converse Hall, for W.L. Converse, who had advanced $15,000 for construction expenses.

When South Georgia State Normal College opened in 1913, the facilities that greeted the new students were hardly luxurious. Richard Powell, the university's first president, bemoaned the lack of an approach to the building, the lack of a bridge between the swamp and the city, and the piles of refuse that were scattered around the campus. (Courtesy of VSU Archives.)

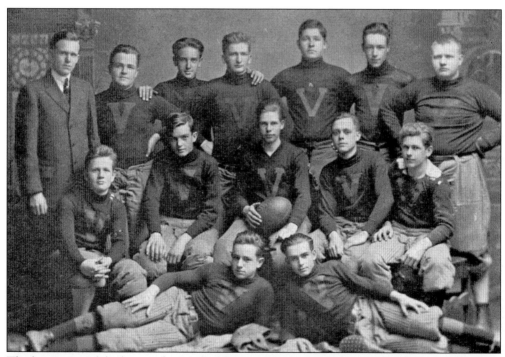

The beginning of the long and storied tradition of football at Valdosta High School is captured in this photograph of the 1913 Valdosta Tigers. This team photograph includes, from left to right, (first row) James Cranford and Jim Tom Blalock; (second row) West Cranford, Lewis Pindar, John Stevens, Eric McIntyre, and Carl Blair; (third row) coach Turner Rockwell, Tom Cranford, Will Collier, Albert Saunders, Oborne Holzendorf, Frank Roberts, and Frank Rose.

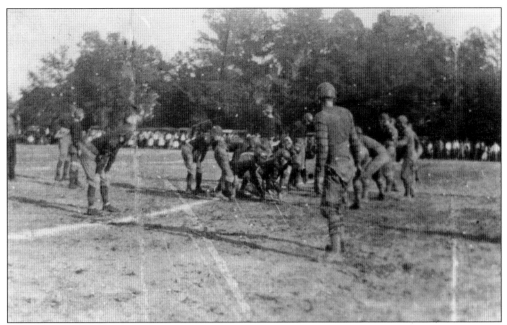

This image from 1915 shows a Valdosta High School football game in progress. The crowds on the sidelines suggest that football had quickly become a very popular sporting event in town. The location of the image is not known, but given the date it was likely Smith Park, which was located between East Hill and East Central Avenues. Smith Park hosted many early sporting events.

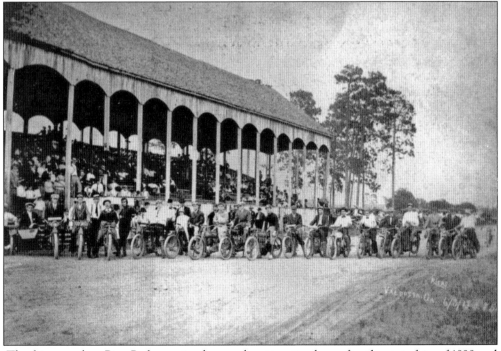

The fairgrounds at Pine Park remained a popular attraction long after the state fairs of 1899 and 1900. The grounds contained a racetrack that featured races by a variety of motorized vehicles. In this picture, motorcycle racers pose with their bikes shortly before a race in June 1913.

The old county jail, nicknamed "Big 12," was located at the corner of South Ashley Street and Florida Avenue. When it was completed in 1912, it was reported to be one of the most modern jails in the South. However, age eventually took its toll, and the building began to crumble after 50 years of service. In 1975, the structure was vacated, and it was demolished soon after.

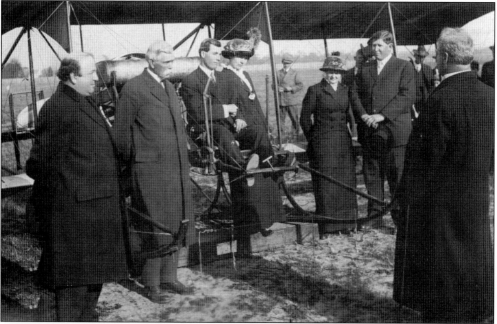

On December 10, 1913, James A. Roberts and Fannie Bussie were married before family and friends at the Pine Park fairgrounds. The Reverend A.L. Johnston of the First Baptist Church performed the service. A visiting stunt flyer who was performing at the fairgrounds provided the unusual prop for the wedding photograph.

George Baker Jr., later called "Father Divine," cultivated his first real following in Valdosta after being released from prison for aggravating Georgia preachers. His congregation consisted of African American women who left their homes and moved in with Baker. He was tried in 1914 for lunacy and was defended by J.B. Copeland. Baker was not convicted but was asked to leave Valdosta. (Courtesy of Peace Mission Church.)

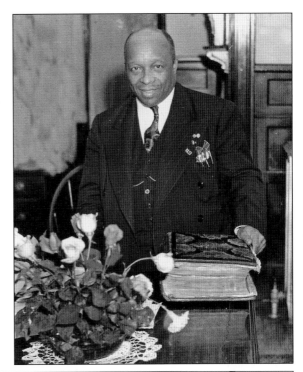

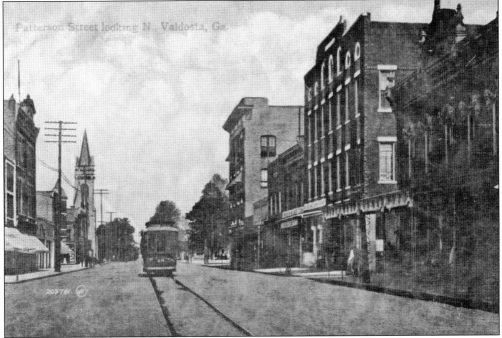

In the early 1900s, the Valdosta Street Railway saw its greatest use. After South Georgia State Normal College opened in 1913, the rail system allowed students at the school to travel downtown for shopping. The railway also gave residents in Valdosta's ever-expanding residential areas a quick ride downtown in the age before the automobile took over and ended the demand for a street railway.

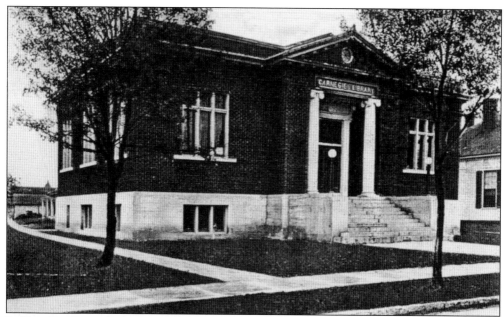

Before the city applied to Andrew Carnegie for funds to build a library, the local library was located in Valdosta City Hall. After receiving a $15,000 grant, Valdosta built a facility on Central Avenue across from the old Valdosta Institute. The library opened in 1914 with Margaret Jamison as librarian. After the building had served its purpose as a library, it became a home for the Lowndes County Historical Society's museum.

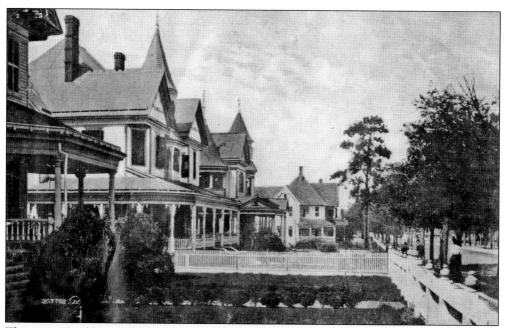

This view of Valdosta has long since disappeared. These well-appointed homes in the 400 block of Patterson Street belonged to, from left to right, T.G. Cranford, Mrs. B.R. Strickland, A.J. Strickland, and Mrs. S.S. Thigpen. These houses all suffered the same fate as many of Valdosta's grand old homes when they fell into disrepair and were demolished.

The Sea Island cotton market was still booming in the early 20th century, as evidenced by this image of the corner of Hill Avenue and Patterson Street (looking east) in 1915. Unfortunately, the boom did not last for many more years. Georgia's cotton production was soon decimated by the boll weevil epidemic of the 1920s, effectively ending the Sea Island cotton market in Valdosta.

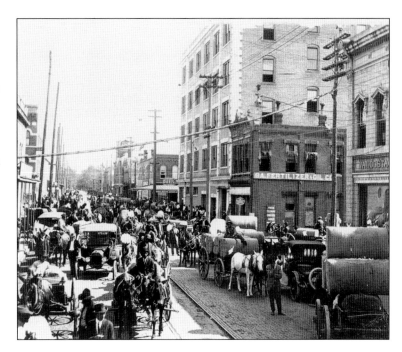

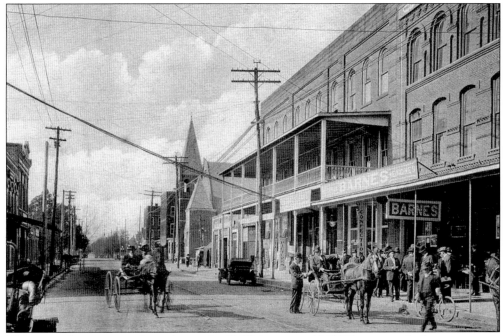

This image shows a somewhat calmer side of Hill Avenue in 1915. This picture looks west towards the First Christian Church and the Valdes Hotel. In the foreground is the Roberts Building, which was occupied by Barnes Drug Store at the time. The automobile had still not come to dominate the town by this point, as horses and buggies are still present.

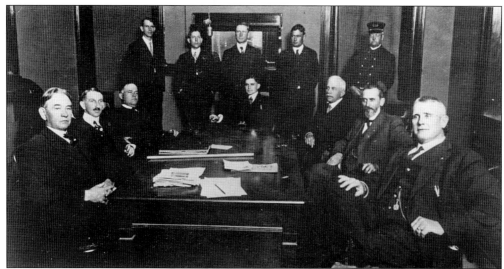

This photograph shows the Valdosta City Council of 1916 at city hall. Mayor T.B. Converse is seated in the middle at the rear of the table. Others in the picture are, from left to right, (first row) councilmen B.H. Jones, J.D. Ashley, M.J. Chauncey, Converse, W.D. Peeples, B.W. Bentley, and W.B. Conley; (second row) quarterman David Sinclair, J.R. Dusenberry, Dr. ? Howell, Bill Gainey, and police chief J.W. Dampier.

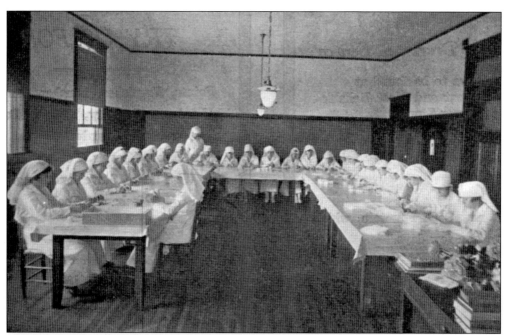

Valdosta eagerly responded to the call of duty when America entered World War I. The students of South Georgia State Normal College were particularly eager to help. This image shows the women of the college folding bandages as part of the one evening a week they devoted to Red Cross work. The president of the college, Dr. Richard Holmes Powell, went on leave to do help the Red Cross. (Courtesy of VSU Archives.)

Three

1920–1945

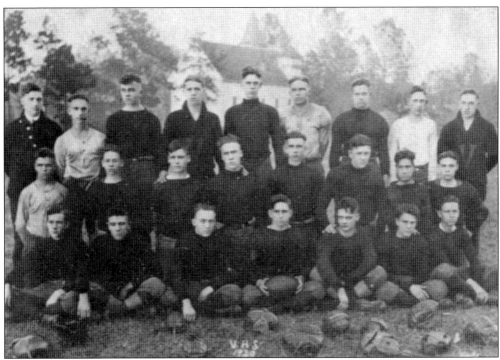

In 1920, the Valdosta High School Wildcats went 8-1 and claimed their first title as a football team under head coach Arthur Cox. They defeated Clarke Central/North Athens 20-13 in a north-south playoff match. The year 1920 is claimed by some as a state title date for the Wildcats, though three other schools claimed the championship that year. Valdosta's first official state title came 20 years later.

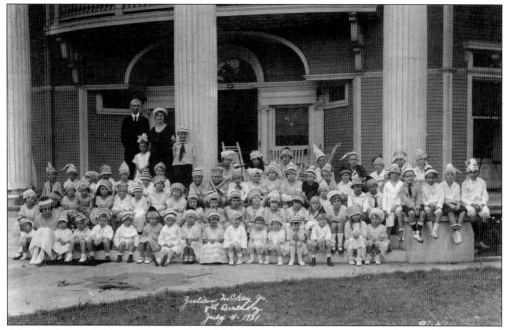

After William S. West passed away in 1914, his widow was quite generous in allowing her home and its grounds to be used for social events. This image shows Julian McKey Jr.'s eighth birthday party, held at the West home on July 4, 1921. The McKey family, including Mr. and Mrs. Julian McKey Sr., their daughter Elsie, and son and honoree Julian, are stand by the column on the left.

Though the Valdosta Hebrew Congregation was first organized in 1908, it went without a synagogue. In the late 1910s, the congregation worked tirelessly to procure funds for a building. By 1919, members had purchased land on Smithfield Place, and construction began later that year. The synagogue, Temple Israel, opened on Rosh Hashanah in 1920 with a membership of 42 families.

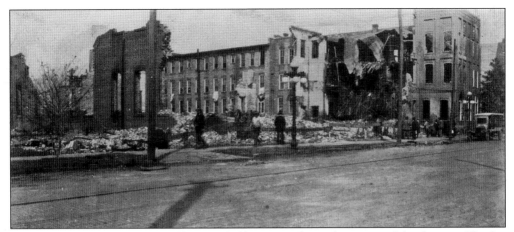

In 1922, a fire devastated the Valdes Hotel. This image shows the extent of the damage. The fire did not, however, signal the end of the hotel. By 1923, it was rebuilt. The new hotel was somewhat smaller than the original; the middle section and west wing were reduced in size.

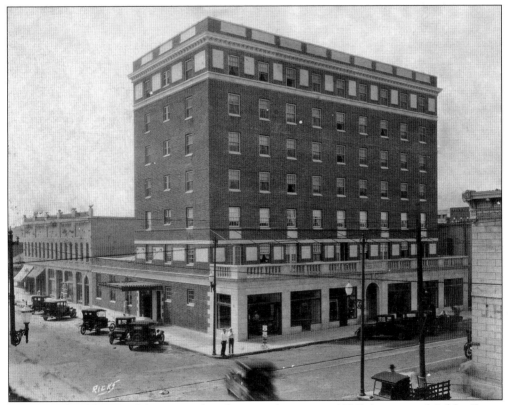

The Daniel Ashley Hotel first opened its doors on the corner of Hill Avenue and Ashley Street in 1927. It quickly became a social center in Valdosta, hosting celebrity guests, local meetings, weddings, banquets, and dances. The hotel featured a row of storefronts as well. The Daniel Ashley closed in 1973 but was reopened in 1980 as the Ashley House, an apartment complex for elderly residents.

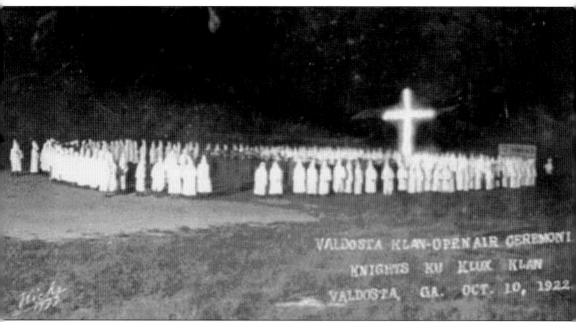

VALDOSTA KLAN-OPEN AIR CEREMONI
KNIGHTS KU KLUX KLAN
VALDOSTA GA. OCT. 10, 1922

The Ku Klux Klan experienced a revival throughout America during the 1920s. This image, which shows an open-air Klan rally in October 1922, suggests that Valdosta had a large Klan population during this time. The success of the KKK was indicative of a time in American history often regarded as a low point of race relations. A tragic by-product of the attitudes of the time was the lynching of a number of local African Americans. In the year this photograph was taken, John Glover was lynched for murder. In 1918, the town and surrounding communities experienced a period of tremendous racial unrest when 18 African American residents were killed in the hysteria following the murder of a white farmer, Hoke Smith. One of the dead was a pregnant woman, Mary Turner, who was killed because she said the large number of lynchings were wrong after her husband was murdered by the mob.

In 1923, the Alamo Theatre opened its doors with a gala showing of *The Still Alarm*. The theater, originally called the Strand, was located on Patterson Street, right next door to the Methodist church. Its name changed back to the Strand Theatre shortly after opening as the Alamo. It remained a theater for several more years. The building stands today, but it has been divided into two shops.

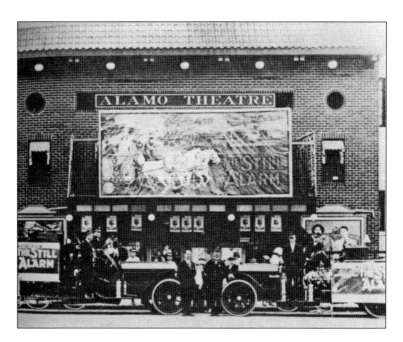

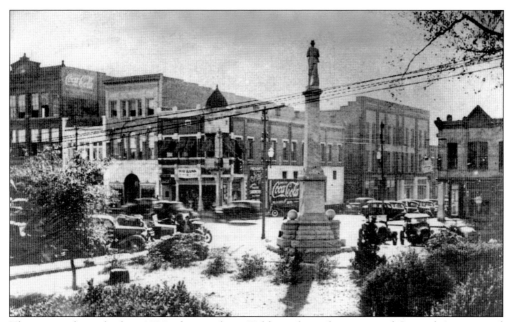

This image from the late 1920s shows a busy Valdosta from the corner of Central Avenue and Patterson Street. Most, if not all, of the buildings in the picture remain today. The structure with the round tower on the south side of Central Avenue is the Varnedoe Building, and the building on the right is the current home of King's Grill, which has operated continuously for more than 60 years.

In 1915, Dr. A.G. Little and Dr. A. Griffin opened the Little Griffin Hospital, which expanded to the Little Griffin Owens Saunders Hospital in 1927. This facility became the medical center for Valdosta during the 1920s and 1930s and was kept up-to-date with the most modern equipment until 1955, when Pineview General Hospital took over as the town's main medical facility.

In 1921, Dr. Frank Bird and Dr. J.F. Mixson started a hospital in an upstairs section of a building at the corner of Central Avenue and Ashley Street. In 1927, they built the brick building shown in this image on the corner of Central Avenue and Toombs Street. By 1932, Mixson had left the hospital, and by the late 1940s, it was no longer open.

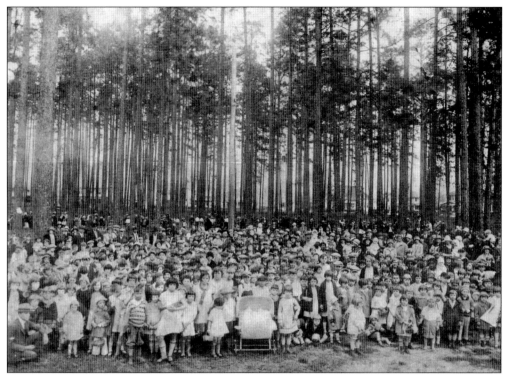

Easter egg hunts were a popular tradition in Valdosta at one time. This image shows a hunt from 1927 that took place on the northern end of the grounds of the college. The dome of West Hall can be seen peeking through the pines in the background of the picture. The city continues to host Easter egg hunts, though they are now held at Drexel Park.

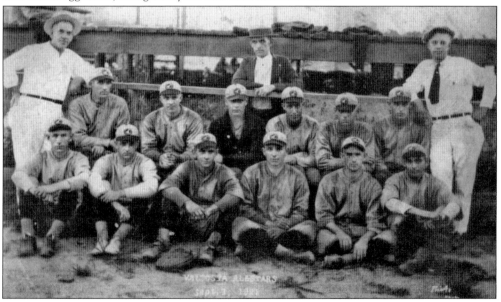

Though football gets most of the attention, baseball has been played for a longer time in the city. Minor league teams had called Valdosta home as early as 1906. This image shows one team, the Valdosta All-Stars, in their uniforms on September 1, 1921, at the ball field in Smith Park.

The Magnolia Street School was the first public school for African Americans in Valdosta. It opened its doors in 1917 and had a considerable number of pupils by the 1920s, when this photograph was taken. The school was located near the end of West Magnolia Street. Its redbrick facade and dual chimneys led some pupils to call it the "horned devil."

The next educational facility for African Americans was the South Street School, which opened in 1922. The school building was demolished, but its campus served as the home of the Pinevale High School, the African American high school in Valdosta until it became a ninth-grade academy after integration.

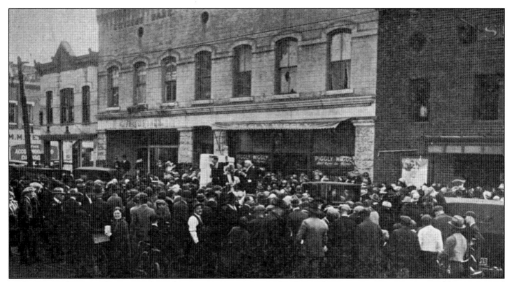

When Piggly Wiggly opened its doors in 1925, it was the first chain grocery store in Valdosta—and also an instant success. The store was owned by two brothers, Robert P. and R. Vaughn Snow. The business was such a sensation that the brothers had to open another location on Ashley Street to meet demand. This image shows just how busy the original Patterson Street store was.

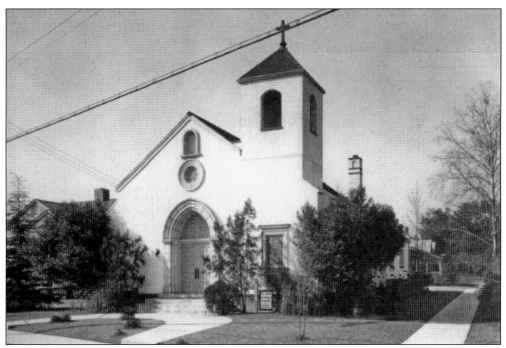

In 1927, a Catholic congregation built a church on Ashley Street. They used the former Adair Street Hospital located behind the church for a parochial school starting in 1941. By 1960, the school and convent had moved to a new location on Gornto Road, and the church had moved there by 1968. The old church building is still standing and has been used by other congregations over the years.

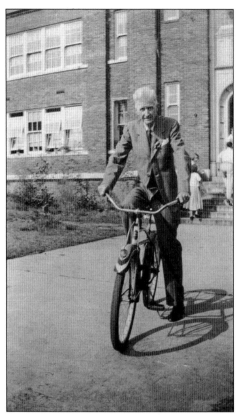

Dr. A.G. Cleveland was first elected superintendent of Valdosta City Schools in 1919 and served until 1949. The football field at Valdosta High School was named in his honor because of his firm belief in physical exercise. Cleveland often rode a bicycle to work and was known to mow the high school campus before the days of motorized mowers; both pursuits show his firm dedication to an active life.

In 1922, under the direction of superintendent Dr. A.G. Cleveland, a new high school building was constructed on Williams Street. The campus included a football field that is still used today by the school. The building received new classrooms and a gym in 1939. The facility served as the city's high school until 1975, when a much larger campus opened on North Forrest Street.

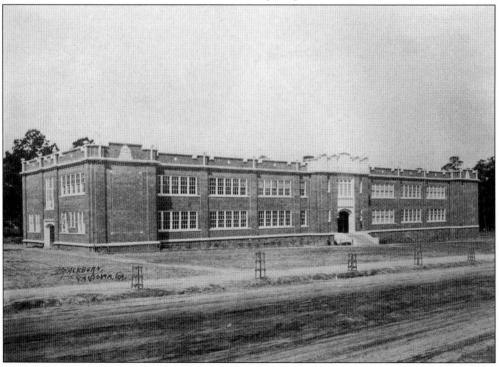

In the fall of 1928, Emory Junior College opened its doors in Valdosta. To make the college a reality, a 43-acre campus, facilities, and $200,000 were given to Emory University. The city and its Methodist congregations worked together to build and fund the school. When it opened, the campus featured ample classrooms, a library, and an auditorium. The institution provided education to men only, which in part helped to seal its fate in the early 1950s, when Georgia State Women's College became coed and changed to Valdosta State College. After the junior college closed its doors in 1953, it became a part of Valdosta State College.

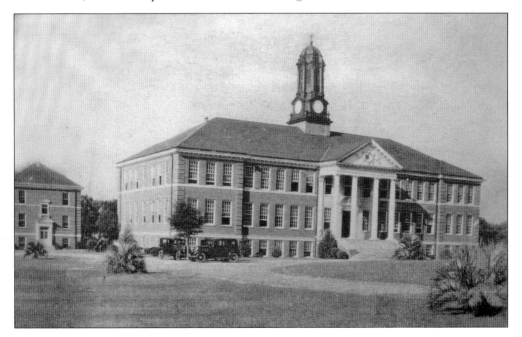

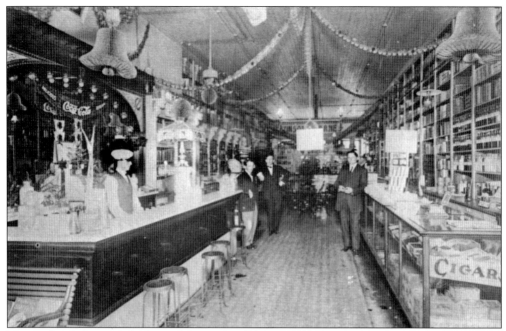

This undated photograph shows the interior of the Vinson Barnes Drug Store decked out for the Christmas holiday. The store was located on North Patterson Street and contained a soda fountain and tobacco counter. It was run by Dr. T.M. Vinson and C.W. Barnes, whose descendants have continued to operate drugstores in Valdosta.

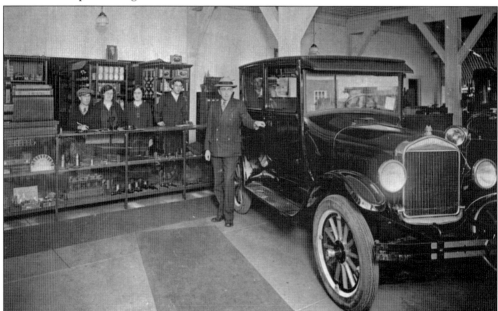

By the mid-1920s, car dealerships were becoming fixtures in downtown Valdosta as the automobile quickly became a necessity. This image shows the interior of the West Motor Company, which was owned by W.S. West and A.A. Parrish. The dealership was located at 123–129 West Central Avenue, and it sold Lincoln, Ford, and Fordson automobiles and tractors. The featured car in this image is a mid-1920s Lincoln Model L.

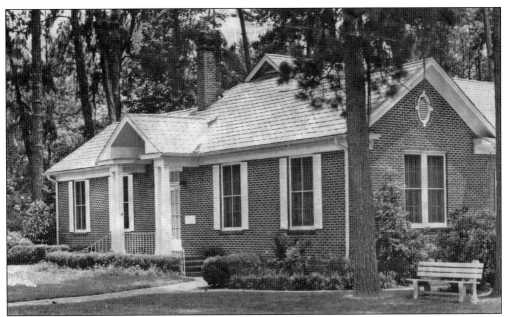

The Wymodausis Club had been organized in Valdosta since 1900, but it did not have an official clubhouse until 1925, when members built a facility on Patterson Street that was for the use of all women's clubs in the city. The United Daughters of the Confederacy, Daughters of the American Revolution, and the Wymodausis Club jointly owned the new Woman's Building. It is still in use today.

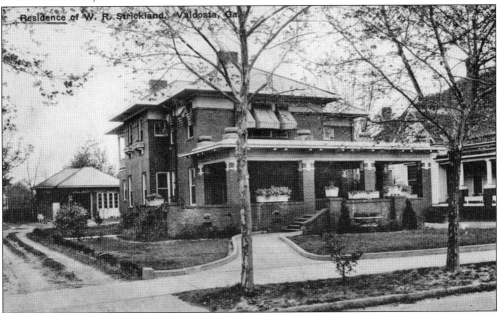

This image shows a historic Valdosta home that has survived to the present. Will R. Strickland and his wife, Rosa, built the house located at 1006 North Patterson Street in 1920. Strickland was the president of Strickland Hardware and had worked as a manager at his father's cotton mill. The Stricklands moved out in the 1930s, but the home remained a private residence. (Courtesy of VSU Archives.)

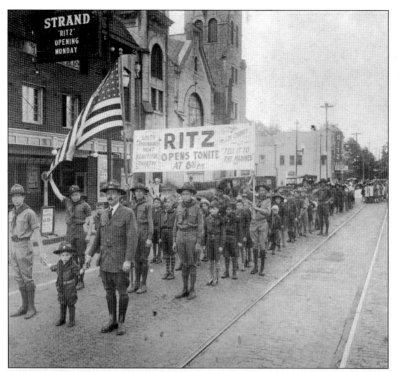

About 10 years after the Alamo/Strand Theatre opened for business, Valdosta was treated to the opening of another movie house. The Ritz opened its doors in 1927 with a gala showing of *Tell It to the Marines* starring Lon Chaney (left). The theater was remarkably well appointed and featured amenities like a Robert Morton pipe organ and an elaborately painted curtain (below).

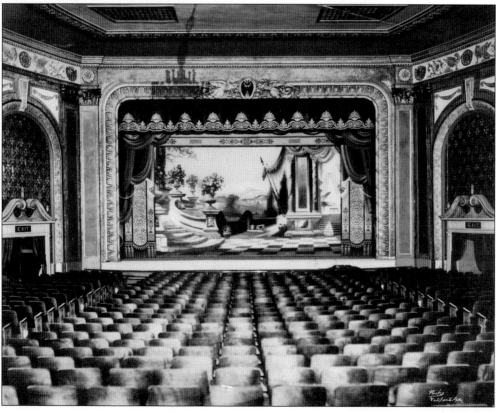

Blind Jim Norman was a well-known peanut vendor who walked the streets of Valdosta selling his wares in the 1930s. Every day, Norman left his home on Thomas Street and walked down Hill Avenue. Though he was blind, residents often marveled at his ability to know his location, the time of day, and the type of coins he received.

Barber's Pool opened in 1921, after E.R. Barber retired from his bottling company. The pool was extremely popular in Depression-era Valdosta. Children begged for rides to the pool or walked there if transportation was not available. The huge slide, spring-fed pool, and snack pavilion were all popular features. In the 1950s and 1960s, the pool's popularity began to decline, and it closed for good in 1965.

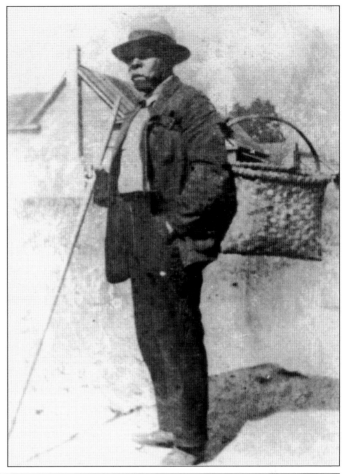

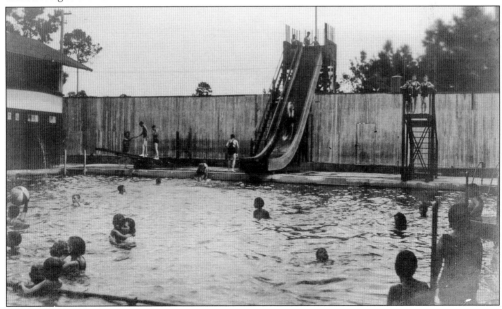

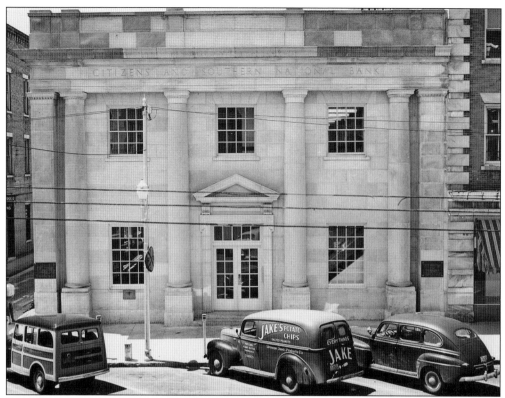

By 1926, the Merchant's Bank of Valdosta had become a part of the Citizens and Southern Bank. Shortly thereafter, the original Victorian building gave way to the larger and more modern facility shown in this image. This particular structure served as the main Valdosta Branch of the C&S Bank until around 1970, when the whole block surrounding the bank was demolished for a new bank building.

In the first half of the 1900s, the dairy business enjoyed a period of great prosperity in Valdosta. At one time, there were several dairy businesses operating in the area. The last one to close was Vallotton's dairy in 1990. This image shows a chamber of commerce banquet to promote the booming dairy industry being held in the milking hall of the Suitsus Dairy.

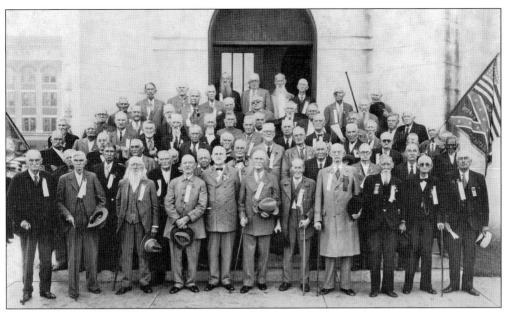

In 1933, a group of Confederate veterans assembled in Valdosta for a reunion. On the evening they arrived, they were treated to a banquet at the Valdosta Country Club, which included a lively cake walk. The next day, they gathered at the First Methodist Church in downtown Valdosta, where they posed for this picture. In the image is Valdostan Raymond Cay, who lived at 205 West Gordon Street.

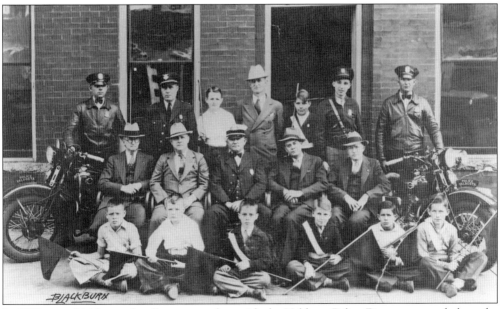

In 1937, some Valdosta schoolboys teamed up with the Valdosta Police Department to help make the town safe. In the picture are, from left to right, (first row) unidentified, James Oliver, Billy Vallotton, Veran Blackburn, and two unidentified; (second row) Dr. J.F. Mixson, Nelse Holcombe, police chief R.L. Kemp, George Lang Converse, and Dr. Joseph A. Durrenburger; (third row) E.K. Cooey, Lonnie Murphy, Gene Jenkins, Dr. T. Baron Gibson, Bill Briggs, Keepee Pitts, and Herman Carter.

For a number of years at the beginning of the automobile age, the Pines Tourist Camp was a fixture on Ashley Street in Valdosta. The facility was owned and operated by H.B. Aldrich, a former circus man from New York. The grounds sprawled over five acres and featured well-appointed cabins, a restaurant, a gas station, and a grocery store. (Courtesy of VSU Archives.)

The growing Baptist congregation that had purchased the old opera house soon needed a new sanctuary. It built this structure to replace the opera house in the 1920s. By the 1950s, this building was replaced with another larger sanctuary, which was sold to the Central Avenue Church of Christ in the late 1990s when the congregation and the Azalea City Baptist Church merged.

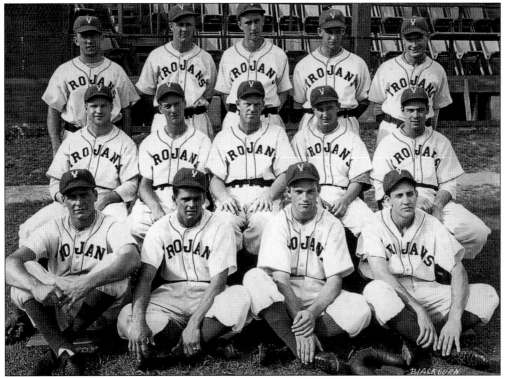

This photograph features the Valdosta Trojans of 1940, who played in the Class D Georgia-Florida League from 1939 to 1942. The team was originally affiliated with the Pittsburgh Pirates but became a farm team for the Brooklyn Dodgers in 1941. Minor league baseball did not leave Valdosta after the Trojans. The city enjoyed the presence of a minor league team until 1958, when the Georgia-Florida League folded.

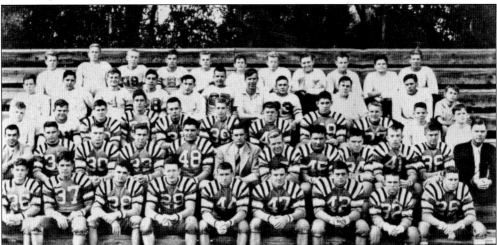

The 1940 Valdosta Wildcats hold the honor of winning the first official state title for Valdosta High School. Under head coach Bobby Hooks, the team went 12-0 and outscored its opponents 346-20. This photograph shows the whole team on the old wooden benches at Cleveland Field. Though he was not yet head coach, this photograph features a young Wright Bazemore seated in the second row on the far left.

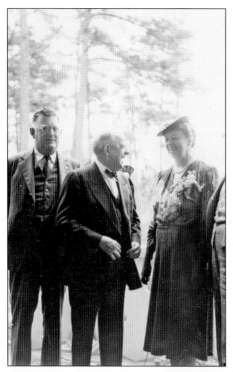

In March 1941, the Georgia State Woman's College completed a new library. The institution's president, Dr. Frank Reade, was friends with Eleanor Roosevelt's father and asked the first lady to dedicate the facility. Roosevelt obliged the request and came to Valdosta, where she stayed with the Reades and dined with the students at the college. The image at left shows Roosevelt on the balcony of the library with Reade (left) and university system chancellor S.V. Sanford. The image below shows part of the crowd of 5,000 that gathered to hear the first lady's speech. The March 29, 1941, *Campus Canopy* quotes Roosevelt's concluding remark, "I dedicate this building to interesting youth and to the strange world in which you live." (Both courtesy of VSU Archives.)

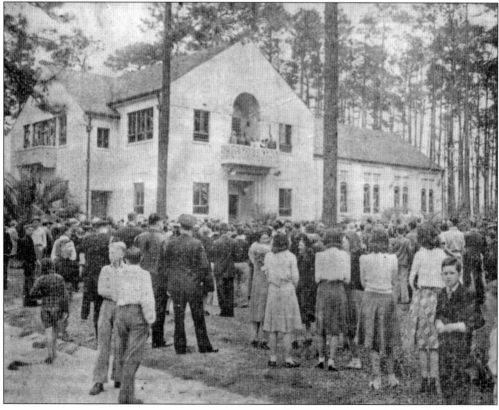

By 1940, local citizens were looking for ways to aid the expanding national defense program. After writing to Maxwell Army Air Field, plans were laid out to open an Army Air Corps base on land 10 miles north of Valdosta. Though construction began in July 1941, the base did not get its identification until 1942, when it was named in memory of Air Corps pioneer George Putnam Moody (right), who was killed in a plane crash earlier in the year. The image below shows nightly retreat activities on the base during World War II. After the war, Moody Field was deactivated for a short period before gaining permanent status in September 1954.

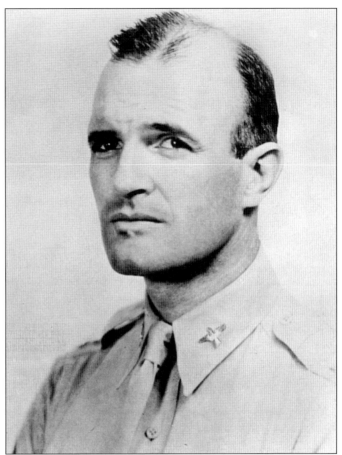

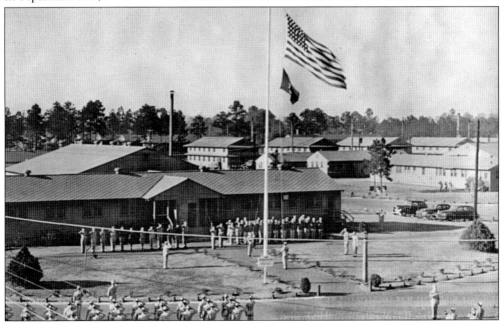

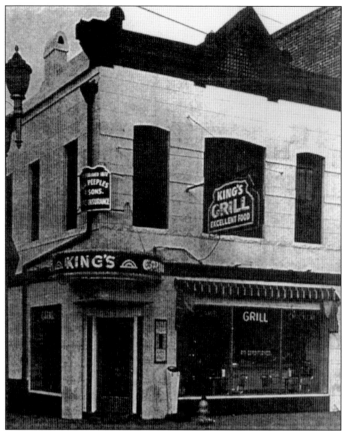

King's Grill, which still operates in downtown Valdosta, first opened its doors in the early 1940s as Jack's Grill. It was originally operated by John J. King. The restaurant was located in a building that had previously served as home to the Youles brothers' confectioners shop and the Valdosta Gas Company.

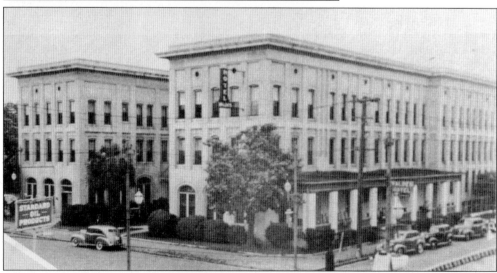

After a fire nearly destroyed the Valdes Hotel, it was rebuilt on the same spot. The newer building was slightly smaller than the preceding building and did not feature the banana trees along the front walls like the original. The lodging remained open until 1962 when diminishing business forced it to close. By 1964, the longtime Valdosta landmark had been demolished to make way for a gas station.

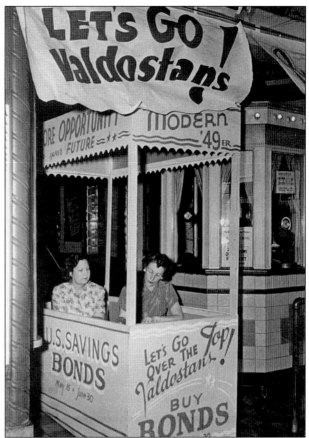

The citizens of Valdosta were very involved in World War II civilian efforts. The community organized a number of drives to make sure they provided all they could to the war effort. The old Valdosta Street Railway tracks were finally torn up during the war years to go toward a scrap drive. The image at the right shows a scrap drive held by students of the Georgia State Women's College in October 1942. War bonds were another popular effort during the war years. The image below shows a US Savings Bond kiosk set up in front of the Ritz Theatre in downtown Valdosta.

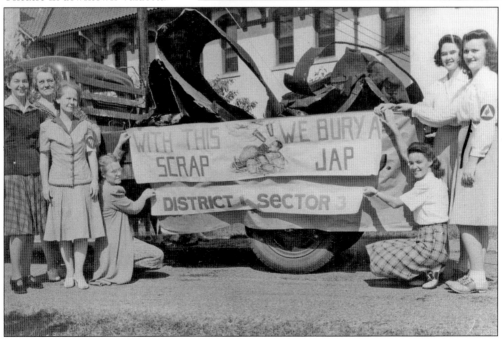

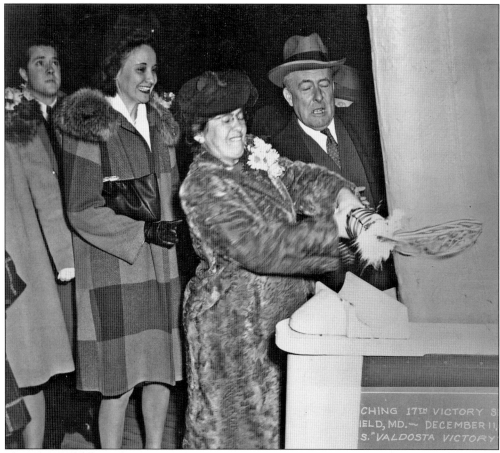

CHING 17ᵀᴴ VICTORY S
IELD, MD.— DECEMBER 11,
.S." VALDOSTA VICTORY

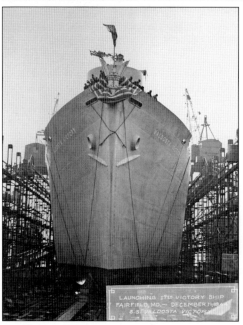

LAUNCHING 17ᵀᴴ VICTORY SHIP
FAIRFIELD, MD.— DECEMBER 11, 1944
S.S. VALDOSTA VICTORY

Valdosta's tireless dedication to supporting the war effort is believed to have been recognized in 1944, when it was announced that a new victory cargo ship was to be named the *Valdosta Victory*. Mrs. G.C. McCrary and Mrs. G.H. Tunison were invited to Baltimore to christen the ship; each was the mother of five sons who had gone off to war. Tunison became ill shortly before the christening and was unable to attend. On December 11, 1944, McCrary swung the bottle and christened the *Valdosta Victory*. The ship was also given a flag explaining its name. The *Valdosta Victory* served for the remainder of the war and in the Korean War as well. The ship was eventually mothballed in a West Coast shipping yard.

Four

1946–1969

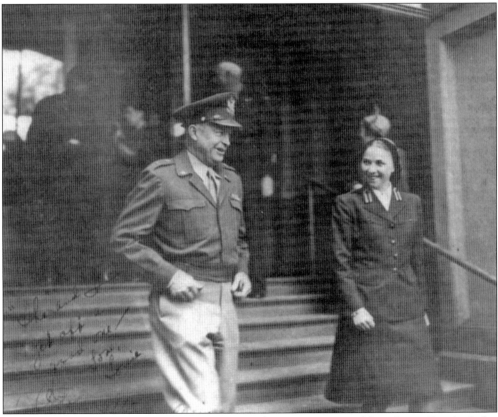

After the war ended, many Valdostans continued serving overseas. Here, Louie Peeples helps escort Gen. Dwight D. Eisenhower on an inspection tour of the American Red Cross Club in Frankfurt, Germany, where she was stationed. Previously, Peeples served at the Rainbow Corner Red Cross Club in London, where she met her future husband, Sgt. Arthur White, who was a correspondent for the Army newspaper *Stars and Stripes*.

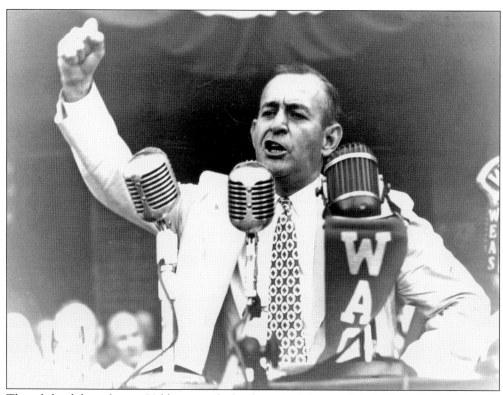

Though he did not live in Valdosta until after he retired from political life in 1956, Melvin E. Thompson is considered "Valdosta's Governor." He became governor of Georgia in 1947 after Eugene Talmadge died in office. The legislature tried to put Talmadge's son Herman in office, but Thompson won legal battles and remained in office until he was defeated by Talmadge in 1948.

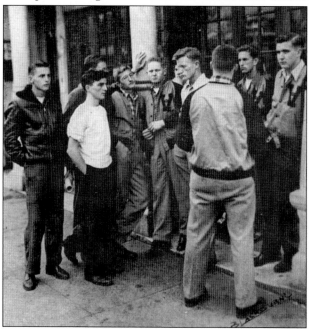

This image shows a group of Valdosta High School students socializing outside of Bob Belcher's drugstore on the corner of Patterson Street and Central Avenue in 1946. Belcher's was located on the lower floor of the Varnedoe building, and in addition to providing medicine, the shop also contained a lunch counter and soda fountain.

In 1946, Valdosta's Episcopal congregation sold the building it had occupied since 1885 and began the process of moving to a new property it had just acquired on the corner of Patterson and College Streets. The structure was completed in 1949 and was modeled after the Bruton Parish Church in Williamsburg, Virginia. The building still serves as Christ Episcopal Church today.

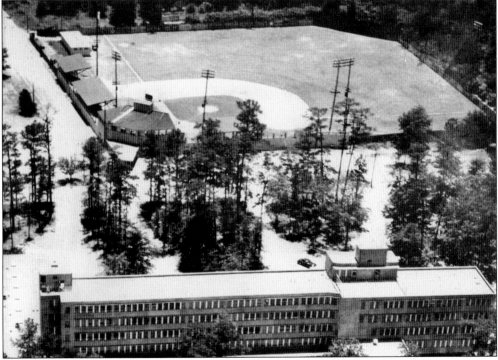

This image shows the home of Valdosta's minor league teams of the 1940s and 1950s, Pendleton Park. The picture also features the newly constructed Pineview General Hospital, which is now South Georgia Medical Center. Pendleton Park was demolished after the minor league team left, and now the former site serves as a parking lot for South Georgia Medical Center.

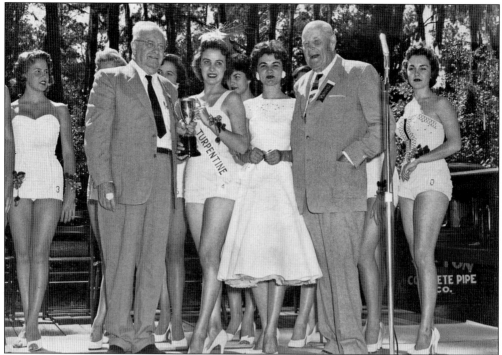

Starting in 1940, the American Turpentine Farmers Association (ATFA) held an annual Miss Gum Turpentine pageant. This undated photograph shows judge Harley Langdale on the right, a longtime president and founder of the ATFA and a judge in a Miss Gum Turpentine pageant. Langdale led the ATFA for 29 years after he helped establish the group. He retired in 1965.

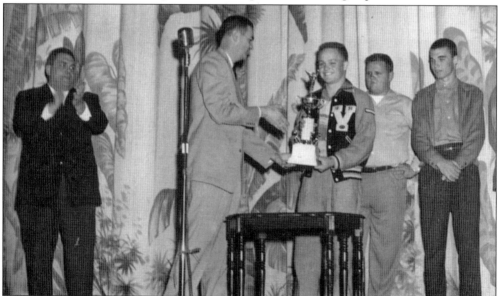

The Valdosta Wildcats received their fifth state championship in 1953. The team went 13-0-1 and outscored opponents 474-66. To celebrate the season, an awards ceremony was held at the Ritz Theatre in Valdosta. In the picture are, from left to right, Noah Langdale Jr., Mayor John B. Giddens, John Robert O'Neal, Paul McNeal, and Willie Webb.

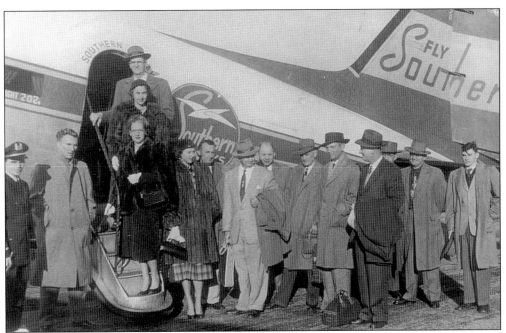

In 1952 and 1953, the Valdosta Wildcats traveled to the Peanut Bowl in Columbus, Georgia, to face an out-of-state opponent in what was referred to as a "national title game." This image shows a group of Valdostans boarding a Southern Airways flight at the Valdosta Municipal Airport to make the trip to Columbus to cheer on their Wildcats.

Pineview General Hospital opened on July 1, 1955, with 100 beds to serve Valdosta and the surrounding area. The facility was funded through a grant made possible by the Hill-Burton Act as well as state and local funding. When the hospital first opened, the rooms had no air-conditioning, which is why the building has so many windows.

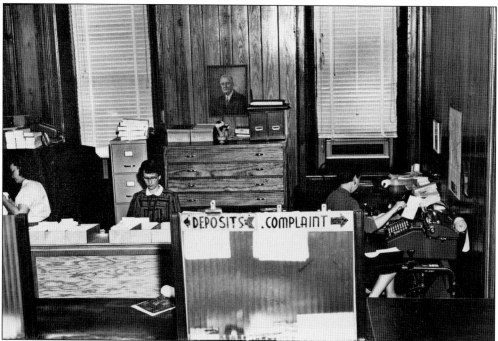

In 1958, the city government moved out of the old Valdosta City Hall on East Hill Avenue and into a new facility on Toombs Street. The image above shows city workers in their offices at the old city hall shortly before they moved out. Soon after the city government moved out of the building, it was demolished, presumably because it was irreparably outdated. The image below shows the old city hall in its final moments before the outer walls were leveled. The site of Old City Hall became a parking lot after the demolition and remains so today.

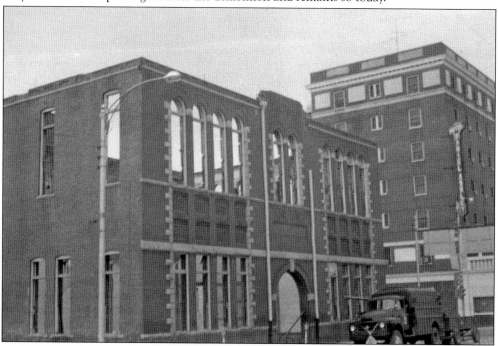

This image shows the modern building at 500 North Toombs Street that housed the city hall from 1958 to 1970. After the city acquired the old post office and federal building, offices moved out of the Toombs Street location, which the police department took over. The building underwent extensive renovations in 1995 and now barely resembles the structure in this picture.

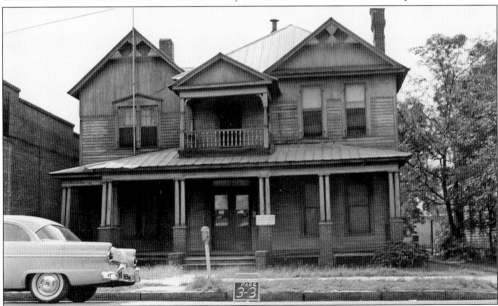

Ever since the Great Depression, a number of Valdosta's large Victorian homes have fallen into states of severe disrepair. The home in this image shows the result of the years of neglect a number of Victorian structures suffered during this time. During the postwar years, a number of grand old Valdosta homes met their end to clear the way for more modern development.

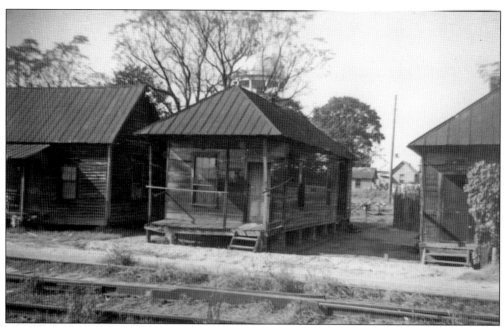

In the 1950s, the City of Valdosta began to focus its efforts on urban renewal. A large number of historic buildings did not survive the process, primarily because of their advanced state of decay. The pictures on this page are from an urban renewal survey conducted in 1958. These homes bordered the railroad tracks on Florida Avenue and highlight the conditions of extreme poverty that African American residents lived in since the city was founded. The state of housing in this section of town, referred to in the past as "Rat Row," had not measurably improved from the late 1800s. These shacks were torn down as a result of renewal efforts, but the region still remains an area of low-income housing.

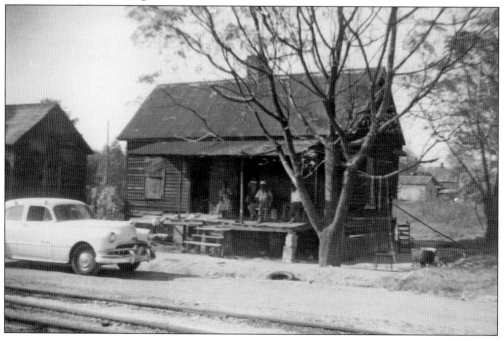

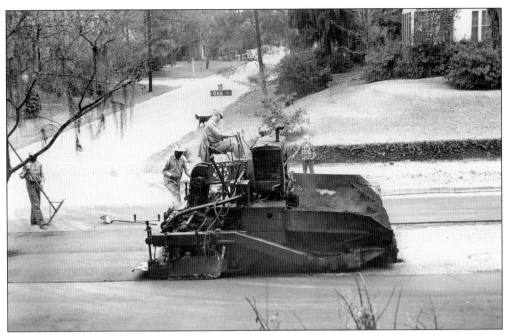

Prior to surfacing in the 1950s, most of Valdosta's main streets remained unpaved. This undated image shows street-paving efforts along North Oak Street at its intersection with West Jane Street. Though some of the main thoroughfares were paved during this period, it seems as though side streets, such as West Jane Street, remained unpaved.

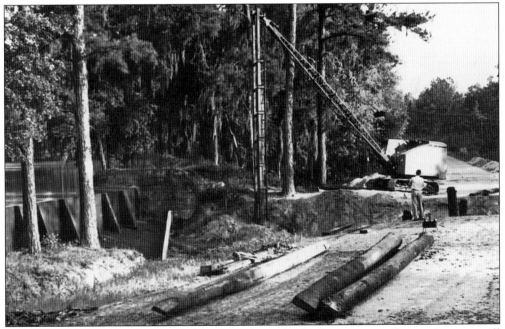

A number of roads that modern Valdosta residents think of as major traffic arteries were still quiet country roads in the 1950s. This image shows efforts to repair the Mill Pond Bridge on Jerry Jones Drive in the late 1950s. At this point in time, there was very little development on Jerry Jones Drive, so the road remained unpaved.

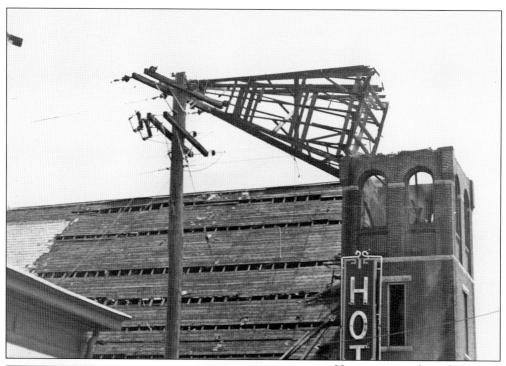

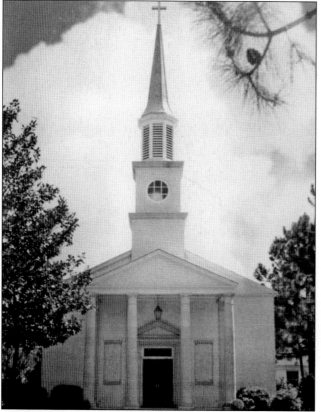

Homes are not the only structures that were torn down during the 1950s and 1960s. After the congregation of First Christian Church moved to a new location on North Patterson Street, the old church building on West Hill Avenue was demolished. Afterward, the site held an appliance store and a service station. Currently, there is a Park Avenue Bank branch location there.

The Lee Street Baptist Church congregation built its third church building in 50 years during the postwar years. The new building served as the church's home until 1999. That year, the congregation merged with members of Azalea City Baptist Church to form Crossroads Baptist Church. After the merger, the building was sold to the Central Avenue Church of Christ, which still occupies the structure.

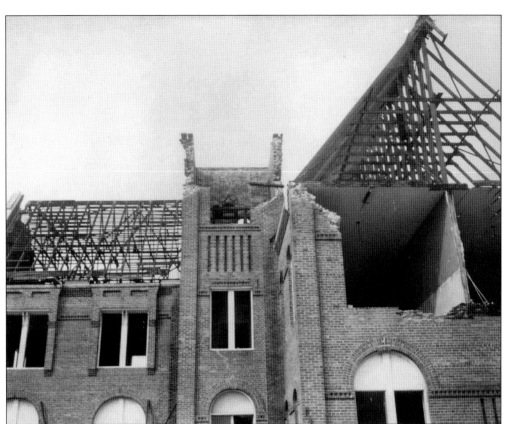

By the late 1950s, the old Valdosta Institute was no longer used as a school. In 1959, it was listed in the city directory for the final time as the Central Avenue Elementary School Annex. By 1961, the old brick building had been razed. These two images show the Valdosta Institute during its demolition. In the above image, wrecking was well underway, leaving a clear view into the building's interior. A close look reveals the school's bell in the bell tower. In the picture at the right, there is a line attached to the second tower before it is torn down. The bell from the school has a home at the Lowndes County Historical Society Museum, located across the street from the former site of the school.

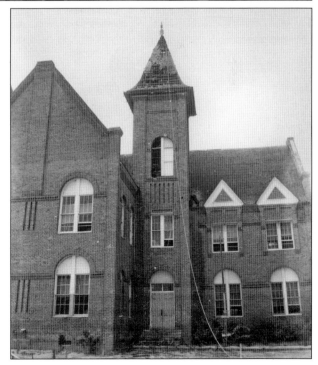

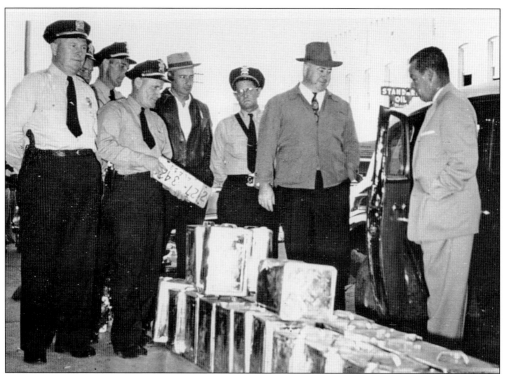

Even years after Prohibition ended, the manufacture and sale of illegal moonshine continued to be a problem for Valdosta's law enforcement officials. In this image, chief of police Wilbur Perkerson and other members of the city police force inspect a large seizure of moonshine. Even with more relaxed liquor laws in Valdosta, there are still periodic busts of moonshiners in the area.

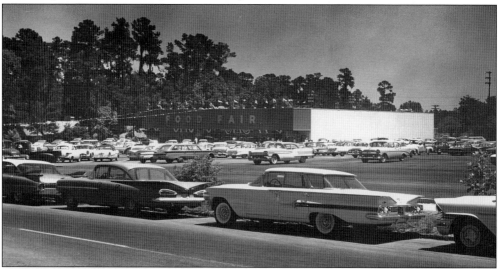

By the end of the 1950s, the city was expanding rapidly northward, and businesses began appearing in what had once been residential areas. The Food Fair grocery store in this image from the early 1960s was located in the 1300 block of Patterson Street near the intersection with Brookwood Drive. According to information from city directories, this block contained homes until the late 1950s.

This image, taken during a parade from the McKey Building at the corner of Patterson Street and Central Avenue, shows a skyline in Valdosta that has significantly changed. None of the buildings visible south of the tallest structure in the picture remain in 2010. Those buildings are south of Hill Avenue and have been replaced by a Bank of America, Barnes Health Care, and the Lowndes County Family Services Building.

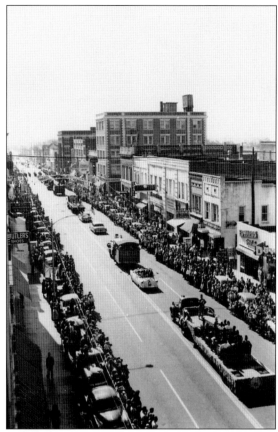

This image shows an event held to show off the new models of Packard automobiles in downtown Valdosta in 1955. The event, called "Packards on Parade," was organized by local Packard dealer John Williams, whose dealership was across the street from the line of autos in this picture. The three young women in the front car are, from left to right, Josephine Bogle, Annette Howell, and Sandra Shaw.

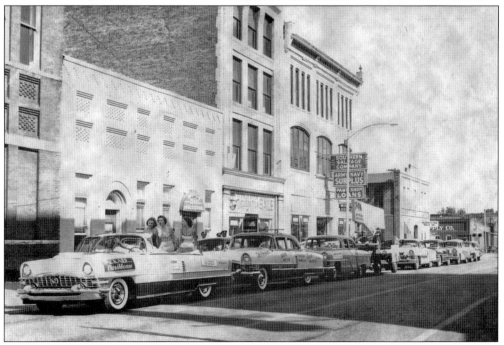

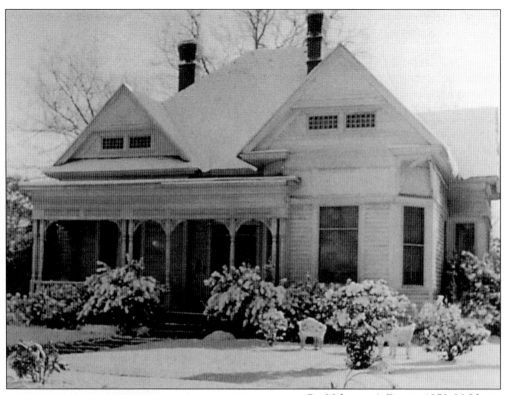

On Valentine's Day in 1958, Valdosta received one of the heaviest snowfalls the town had ever seen. Snow is not a common occurrence in the region, and it caught many residents off guard. The city reportedly received more than two inches of snow during the overnight storm. The snowfall helped add a rarely seen winter look to Valdosta's old homes.

James L. Lomax was a pivotal leader of the African American educational community. He began his career in Valdosta as the principal of the Magnolia Street School in 1923. Later, he became principal of Dasher High School, another African American school, where he served until his retirement in 1967. In addition to his educational duties, Lomax served as Macedonia First Baptist Church's pastor for 34 years.

Louis L. Lomax, the first African American broadcast journalist, was born in Valdosta in 1922. He was taken in as an adopted son by James L. Lomax and attended Dasher High School. The younger Lomax was instrumental in bringing the Nation of Islam to the attention of the American public and worked tirelessly as a civil rights activist until his death in a car crash in 1970.

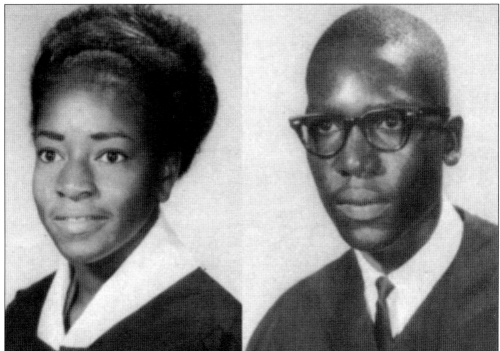

Integration in Valdosta came more quietly than in other communities in the South. Valdosta State College was the first to integrate in 1964. Drewnell Thomas, left, and Robert Pierce, right, were the first students to enter the school. There was opposition, but no disorder came from the small protests. The city schools did not begin to integrate until a few years later and finished in 1970. (Courtesy of VSU Archives.)

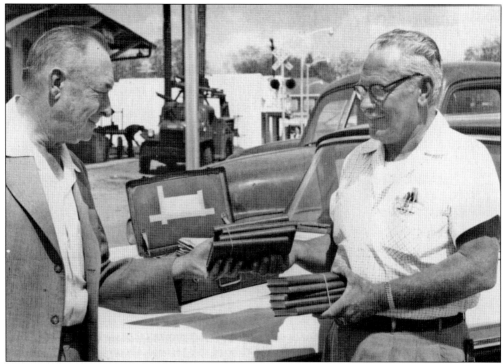

The arrival of the first locomotive in 1860 signaled a new era in transportation for the residents of Lowndes County. The late 1950s saw another age in transportation as the Interstate Highway System made its way into Valdosta with the construction of Interstate 75 a few miles west of downtown. This image shows the survey books for the new roadway being handed off at the old train depot in 1957.

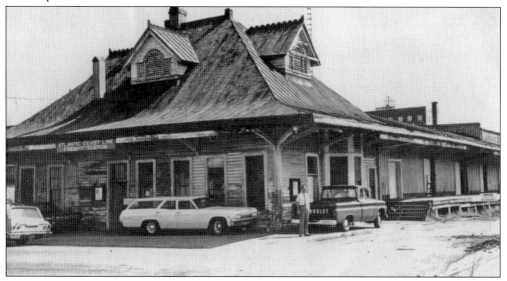

After the arrival of the interstate, much of downtown Valdosta, including the old rail depots, began to decline. Traffic was no longer circulating through the area as much, and the appearance of buildings in the region reflected the new reality. This image shows the old Atlantic Coast Line Railroad freight depot in its last days in the 1960s. It was torn down by 1969.

W.G. Nunn was the superintendent of Valdosta City Schools from 1948 to 1968. During his time in this position, a number of new facilities were constructed as the system continued to grow. At the very end of his tenure as superintendent, Nunn was involved with the desegregation process in Valdosta.

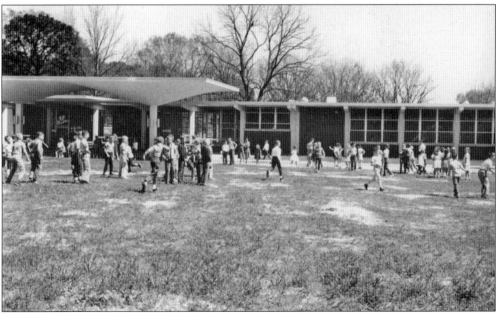

This picture shows one of the new elementary schools built while W.G. Nunn was superintendent. The school was named after Stuart L. Mason, a member of the Valdosta Board of Education. The school, located on Azalea Drive near Valdosta State University, moved to West Gordon Street in 2008. The old campus still stands and is currently the home of the Valdosta Early College Academy.

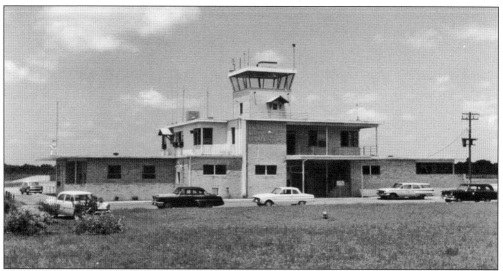

The Valdosta Municipal Airport, located on Madison Highway on the south side of town, began to expand during the postwar period. The airport added a passenger terminal in 1949, providing the first commercial passenger service in Valdosta. This image shows the new air terminal and control tower in the late 1950s or early 1960s. The terminal is still standing, though a new passenger terminal was constructed later.

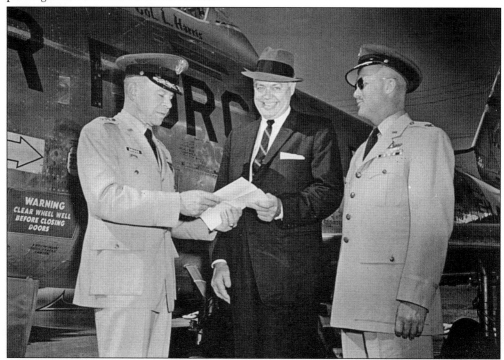

On June 20, 1961, the city of Valdosta accepted a "present plane" from the Air Force. The aircraft in this picture is an F-86L, a type of plane that was used in training exercises on the base. The fighter still sits at the corner of Woodrow Wilson and Ashley Streets near Mathis Auditorium. In the picture are, from left to right, Gen. James Elbert Briggs, Mayor Maxwell Oliver, and Col. Les Harris.

Interstate 75 was completed in Lowndes County in the early 1960s. This image shows the newly completed highway at the exit of St. Augustine Road in 1967. The area around this interchange developed substantially in the intervening years and is now one of the busiest parts of Valdosta.

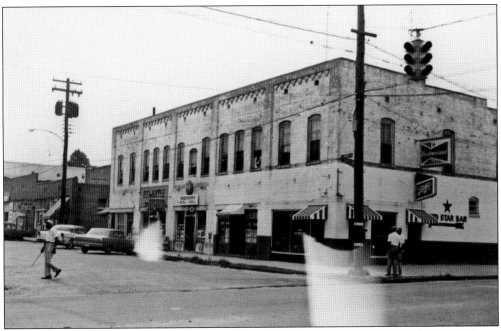

Taken from the corner of South Ashley Street and East Crane Avenue in 1962, this image shows a segment of downtown Valdosta that has completely disappeared. Robinson's Hotel and Grill, Red Star Package Store, and the Skyline Café are all visible on the 100 block of East Crane. The entire block is no longer in existence. It would be directly under the downtown overpass if it still stood.

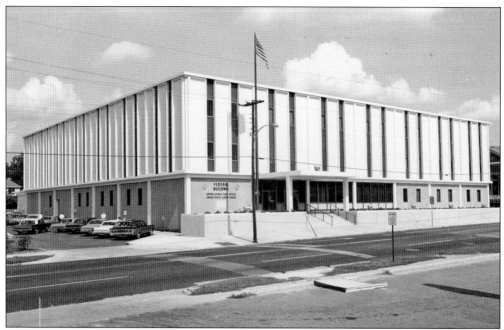

In 1969, a new post office and federal building was completed on North Patterson Street. The structure sat on the corner of Magnolia and Patterson Streets just north of the Presbyterian church. After the building was finished, the post office moved out of the building it had occupied since 1910, which was purchased by the city for use as a city hall.

In 1968, a new Catholic church was consecrated on Gornto Road where St. John's Catholic School had operated since 1959. The church, school, and convent are all still in use today. The grounds underwent their most recent renovations in 2003, when the sanctuary was enlarged and new school buildings were added.

In October 1964, First Lady Claudia "Lady Bird" Johnson embarked on a whistle-stop tour of Southern cities to support her husband's presidential reelection bid. She stopped in 47 cities in four days during the tour that was dubbed "the Lady Bird Special." Those who resented her husband's stance on civil rights legislation received Johnson coldly in many Southern towns. One of her stops was in Valdosta, where she was met by a friendly crowd of 7,000 people who gathered to hear her give a speech. The image at right shows part of the crowd gathered at the intersection of Patterson Street and Savannah Avenue. The image below shows Johnson delivering a speech from the back of a train.

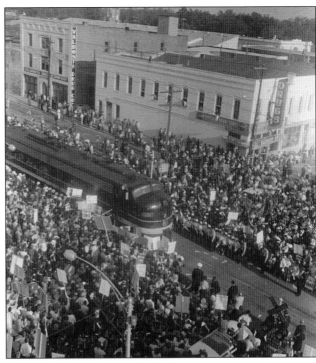

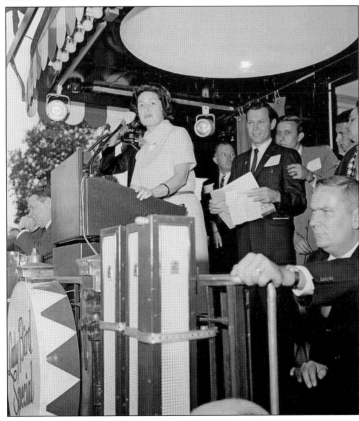

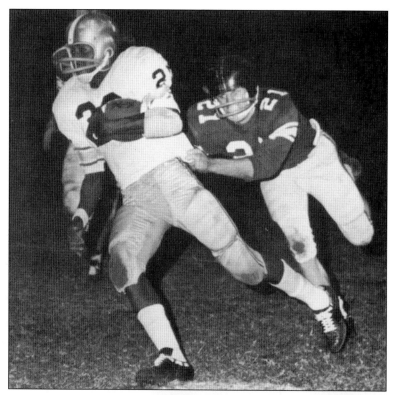

One of the biggest football nights in Valdosta is the annual matchup between Lowndes High School and Valdosta High School. The rivalry began in 1968, long before the game was dubbed "the Winnersville Classic." This image shows a glimpse of the first matchup. The brand-new football program at Lowndes was no match for the well-established Wildcats, who won the game 48–6.

In 1969, the Wildcats captured their second shared national championship in high school football. This capped off one of the most impressive decades in the history of the Valdosta High School football program—the team won seven state championships and two national championships. This image shows the coaching staff during this era. From left to right are Joe Wilson, Jack Rudolph, Julian LeFiles, Charles Green, and Wright Bazemore (kneeling).

Five

1970–1989

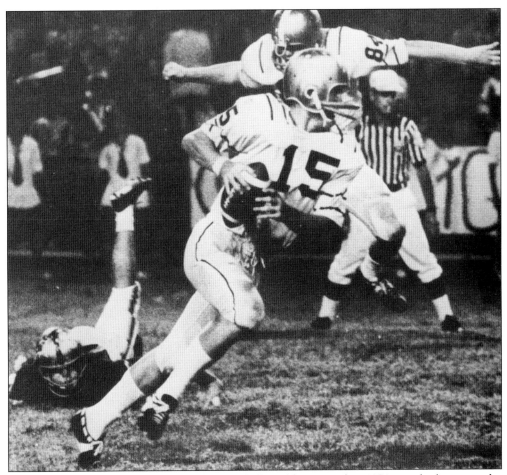

Those who follow Valdosta High School football could suggest that 1971 was the best year the Wildcats ever had. In Wright Bazemore's last season as head coach, the team went unbeaten and claimed its second national title in three years. In this image, quarterback Stanley Bounds evades a defender. This year is also memorable because the number-two team in the nation was later commemorated in the 2000 film *Remember the Titans*.

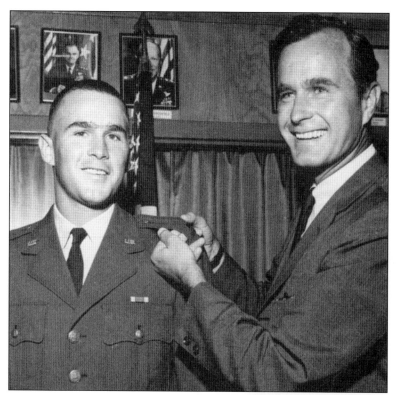

When former president George W. Bush was in the Air National Guard, he did his training at Moody Air Force Base. He was at Moody from November 1968 to November 1969, and his instructor remembered him as a good pilot. Bush also dated a cheerleader from the college during his stay in Valdosta. This image shows his father, former president George H.W. Bush, pinning on his son's wings at Moody.

In 1972, the city of Valdosta elected its first woman to a seat on the city council. Bette Bechtel was a biology professor at Valdosta State College and had worked at Pineview General Hospital as a registered nurse before becoming an educator. Since Bechtel's term in office, only three other women have sat on the council.

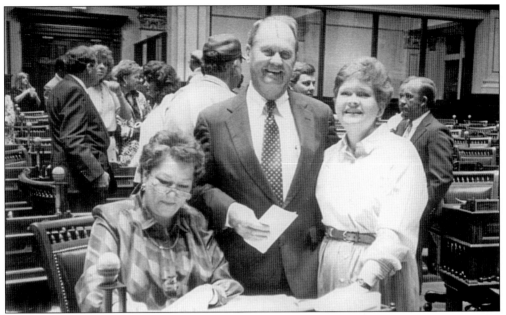

Loyce Turner was a state senator from Valdosta for 24 years, 1975–1998. During his tenure, he held several committee chairmanships and introduced several important pieces of legislation, including the bill to grant Valdosta State College university status. This image shows Turner on qualifying day at the capitol in Atlanta in 1974. He stands with his wife, Annette Howell Turner, while the secretary of the senate processes his paperwork.

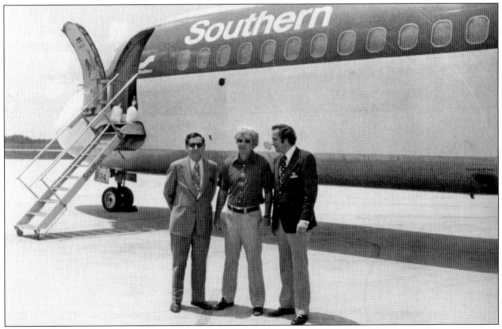

In 1974, the Valdosta Municipal Airport took another step forward and began to offer passenger jet service from Southern Airways. The airport still offers service today though Delta Airlines. Pictured in front of a new airplane are three prominent Valdosta businessmen. From left to right are James M. Beck, Ferrell Scruggs, and Gil Harbin.

By the end of the 1960s, the buildings surrounding the C&S bank on South Patterson Street had been vacant for years. In the early 1970s, the entire block of structures was torn down and replaced by a single new facility for C&S bank. This large brick building remains today and serves as the main Valdosta branch of Bank of America.

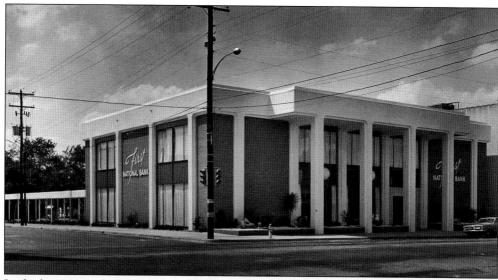

In the late 1960s, the First National Bank building replaced the Bassford Service Station at the corner of Patterson and Valley Streets. In 1973, shortly after this picture was taken, the Ritz Theatre, which sat just north of the bank, was torn down to accommodate an addition to the bank. Both the original building and the addition stand today and serve as offices for the Lowndes County government.

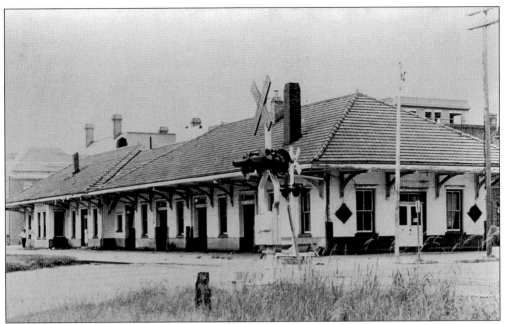

The 1970s proved to be the final years for the old passenger railroad depots of Valdosta. These images show both depots in the late 1970s, shortly before they were demolished. The above picture is of the old Atlantic Coast Line Railroad passenger depot, which had been remodeled in 1910, at an unspecified time shortly before it was demolished. This depot sat facing Savannah Avenue between Patterson and Ashley Streets. It was torn down when the James Beck Overpass was built in 1982 and was replaced by a parking lot. The Gulf South and Florida Depot, which sat at the corner of Florida Avenue and Patterson Street, is featured in the image below, which was taken around 1976. It was torn down around 1980 and is currently the site of a park.

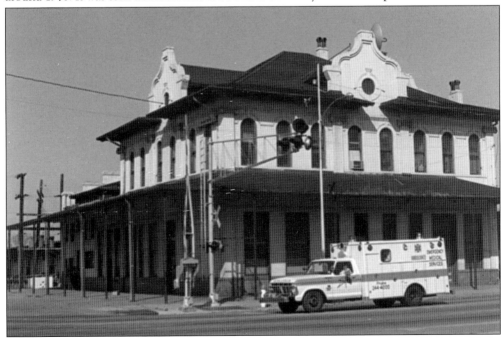

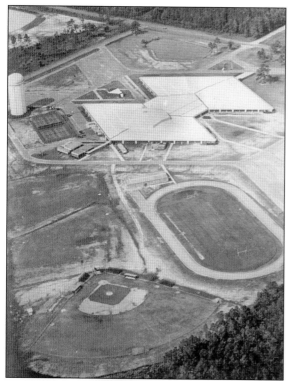

In August 1973, Valdosta High School moved to its current location on Forrest Street, near the intersection with Perimeter Road. This image shows an aerial shot of the newly completed four-acre facility, which cost $5 million to build. This campus is still the home of Valdosta High School today.

Nearly one year after Valdosta High School opened its new campus, the original Valdosta High School building was torn down. Over the years, the building served as a high school, junior high school, and an elementary school. However, the structure declined greatly in the years before its demolition, and upkeep became too expensive. The site of the building became a parking lot for the First Baptist Church.

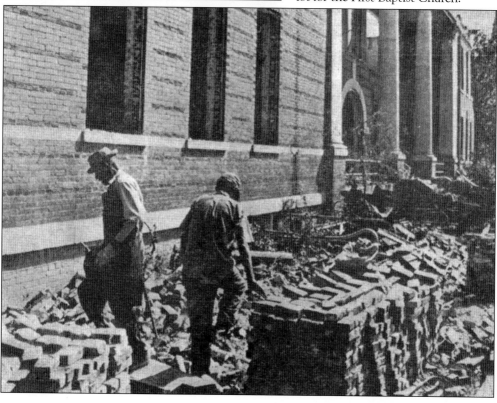

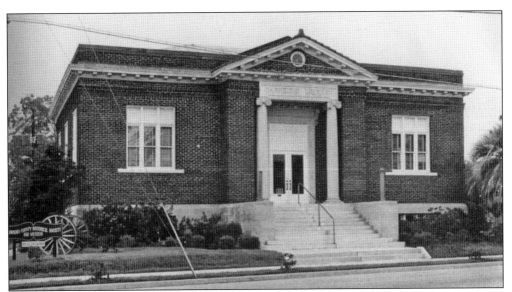

Not all buildings that had become obsolete in Valdosta were demolished. Some found new life for other purposes. After the library moved out, the original Carnegie building was repurposed as a home for the Lowndes County Historical Society and Museum. The museum has operated at this location on Central Avenue since 1977.

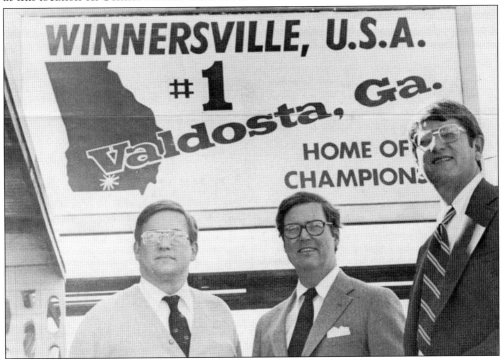

In 1977, *Valdosta Daily Times* sports editor Mike Chason came up with a new name for Valdosta to recognize the city's winning tradition in many sports. He dubbed Valdosta "Winnersville, USA." The name was readily accepted by the town, which was happy to promote it. This image shows John B. Lastinger, middle, with Wade Coleman, right, posing in front of one of the many "Winnersville" billboards that had gone up around town.

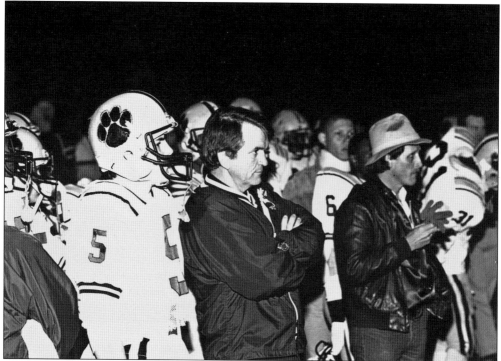

After Wright Bazemore retired in 1971, the Valdosta Wildcats spent two years under head coach Charlie Greene before Nick Hyder took over. Hyder believed in tough discipline and ethical conduct by his players and did not tolerate misbehavior. Though his outlook meant early losses for the Wildcats, it soon turned into a total of seven state championships, three national championships, and appreciation from even his most bitter rivals.

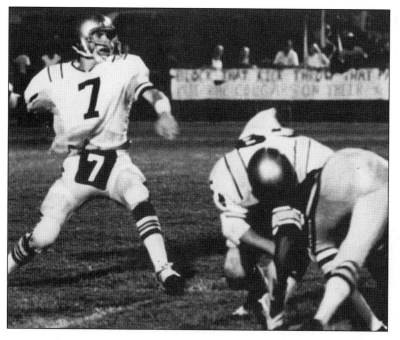

In 1980, the Georgia Bulldogs won a national championship with a former Valdosta High School player at starting quarterback. Buck Belue played for the Bulldogs from 1978 to 1981 and led the team to two Southeastern Conference titles in addition to the 1980 national title. This image shows Belue in action for Valdosta High during his senior year in 1977.

Within the span of six months in 1977 and 1978, two iconic symbols of education in Valdosta burned to the ground. The old Valdosta High School, pictured above, was retired in 1971 but was being used as offices for some Lowndes County departments when it caught fire in November 1977. The cause of the blaze was determined to be combustible art supplies housed in the building. The fire damaged the school beyond repair, and the building was razed soon after. Converse Hall, which was the oldest building on the Valdosta State College campus, burned down on April 14, 1978. The building, which is pictured below during the fire, was still actively used as a student dormitory at the time of the fire. The blaze was apparently started by a cooking mishap in one of the dorm rooms.

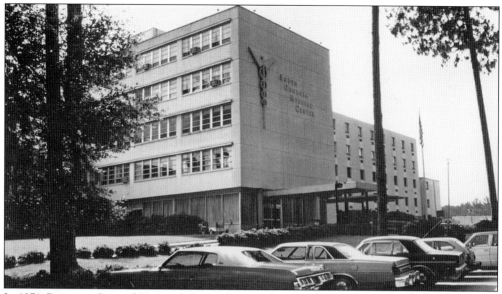

In 1971, Pineview General Hospital changed its name to South Georgia Medical Center to reflect the hospital's growing responsibility to a regional service area. During the 1970s and 1980s, the hospital's services and facilities expanded rapidly. The hospital added regional EMS, mental health services, a cancer center, and more during this period. This image shows the medical center before a $26-million expansion began in 1982.

Gil Harbin had only been in Valdosta a few years when the Ohio native was elected mayor in 1974. Harbin was a promoter of industry and brought several companies to the town. He also wanted to ensure the companies were a good fit for Valdosta and that they would give something back. Because of his contributions, the street that runs through the local industrial park is named in his honor.

In 1979, Valdosta State College won its first national championship in baseball. The achievement surprised some, who felt the team lacked any distinguishable talent. The one talent the team did appear to have was winning games, which they continued to do until they had captured the NCAA Division II National Championship.

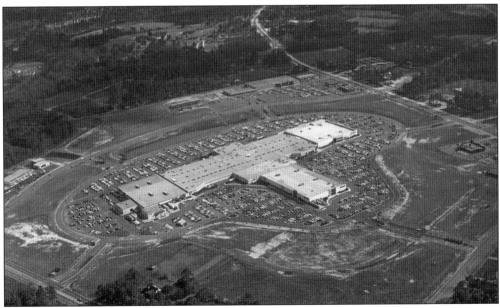

In 1983, the Valdosta Mall opened its doors, helping to spur rapid economic development in the surrounding area. A number of major businesses relocated to the mall and its surrounding areas as well, leaving old shopping plazas like Brookwood Plaza and Five Points Shopping Center. This image is an aerial view of the mall shortly after it opened, before major development occurred.

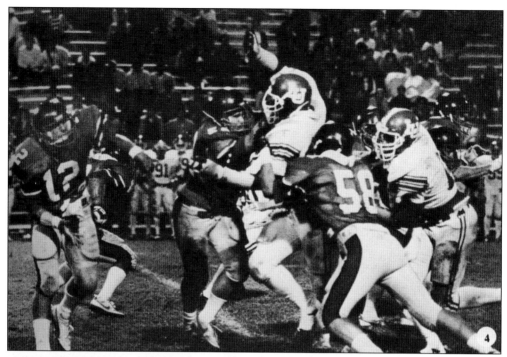

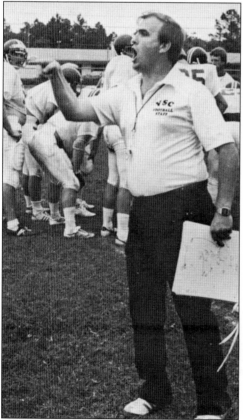

In 1982, the students of Valdosta State College voted overwhelmingly to raise student fees to fund a football team. That fall, the team took to the field for the first time. The image above shows a scene from the 1982 season. The image at the left is the team's first head coach, Jim Goodman, who had less than 10 months to prepare his team of newcomers to play football. Despite the long odds, Goodman and the Valdosta State Blazers managed to finish the season with a 5-5-1 record, which was better than predicted for the team. The Blazers came a long way since that first season and have since won the NCAA Division II National Championship twice, in 2004 and 2007.

Though Valdosta High School had played Lowndes High School since 1968, the first time the game took on the name "the Winnersville Classic" was in 1981. Valdosta handed the Vikings another defeat, 20-13, in the first named version of the rivalry. In recent years, the Vikings have become the favorite in the annual rivalry game, though Valdosta still has a 33-15 record overall in the series.

The winning football tradition at Valdosta High School was on display again in 1984, when the team was awarded its fourth national championship by the National Sports News Service. It was the first of three national championships the team collected under the leadership of coach Nick Hyder. From left to right are Matt Standaland, Trevor Shaw, Jim Godbee, and Jodie Sprenkle on the sideline during the 1984 season.

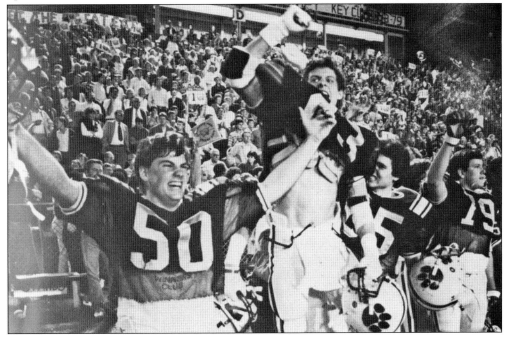

By the late 1970s, most of downtown Valdosta had fallen into a serious state of disrepair. The arrival of the interstate highway had routed a large amount of traffic away from the old center of town since the early 1960s. The images on this page show some of the vacant buildings in the downtown area during this time period. The photograph above is of a row of run-down and mostly vacant stores on South Ashley Street near the intersection with Branch Street (now Martin Luther King Drive). The picture below shows mostly empty storefronts in the 100 block of South Patterson Street, between Hill Avenue and Savannah Avenue. Though the buildings shown here were mostly unoccupied and in disrepair during this time, they have all survived to the present day.

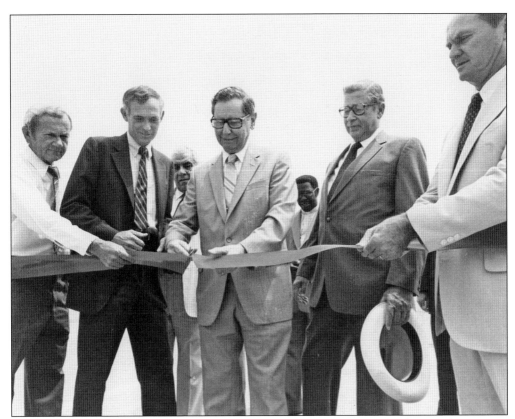

The train tracks in downtown Valdosta had long been a source of traffic backups and commuter frustration. An overpass was in discussion since the 1960s, when Mayor James M. Beck began petitioning for its construction. Little progress could be made until the state legislature allocated funds for the overpass in 1980, while Beck was a state legislator. After two years of demolition and construction, the James Beck Overpass opened to traffic in June 1982. The picture above shows the ribbon-cutting for the overpass, held on August 5, 1982. From left to right are Robert Patten, Tom Moreland, James M. Beck, Henry Reaves, and Loyce Turner. The image below shows the overpass in 1986 from the roof of the McKey Building on Patterson Street. Changes to the landscape over the years are apparent in a comparison of this photograph with the image on page 91.

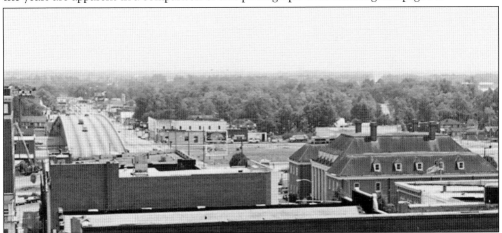

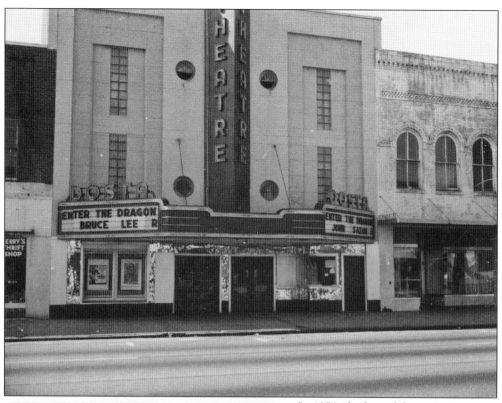

In 1979, the last of the majestic downtown theaters, the Dosta Theatre, closed its doors. The Dosta was the last of the theaters to arrive in the area, opening in 1939. The cinema featured a stylish Art Deco facade that was a standout on Ashley Street since it opened. The building is now occupied by Theatre Guild Valdosta, which uses the facility for its productions.

In 1988, Valdosta State College defensive standout Jessie Tuggle was drafted by the Atlanta Falcons and became the first player on a team from Valdosta to make it to the NFL. He had a long career with the Falcons and continued to support his alma mater, which named the Jessie Tuggle Fitness Center in his honor. (Courtesy of VSU Archives.)

In 1987, Moody Air Force Base received its first contingent of F-16 fighters to replace the F4-E fighters that the 347th Tactical Fighter Wing had flown since the base became part of Tactical Air Command in 1975. F-16s flew at Moody until the base moved away from fighter operations. The last F-16s at Moody were relocated by June 2000.

In 1988, James H. "Jimmy" Rainwater became mayor of Valdosta. He went on to be the longest-serving mayor in the history of the city. During his 15 years in office, Rainwater consolidated considerable power and became known as a man who was all things to the city of Valdosta. In 2003, Rainwater faced a serious electoral challenger but passed away a few weeks before the election.

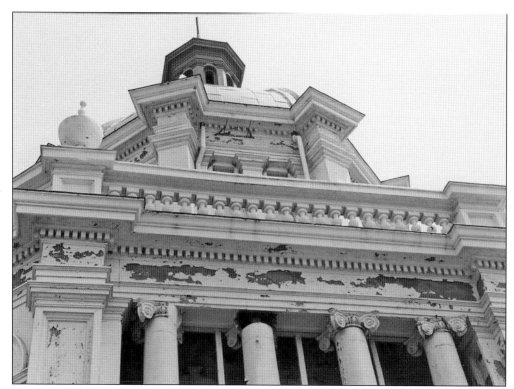

By the 1980s, the county courthouse had fallen into a state of disrepair. This image shows the extent of the deterioration that occurred in the building's 80 years of existence. By May 1987, an extensive renovation was completed that helped make the courthouse accessible to the handicapped, restored its historical features, and modernized the structure where possible.

After the overpass was completed, the question of what to do with the Seaboard tracks remained. Though efforts to have the tracks moved began in 1983, an agreement was not reached until 1988, at which time the tracks were shifted slightly south from their old location that paralleled Savannah Avenue. (Photograph by Bob Lupinek; courtesy of *Valdosta Daily Times*.)

Six

1990–2010

Though the James Beck Overpass successfully ended delays from passing trains, its construction delayed train traffic on the Seaboard line for nearly eight years. From the time the overpass opened in June 1982 until May 1990, no trains ran through downtown Valdosta on the Seaboard line, which had to be moved slightly south from its original location on Savannah Avenue. (Photograph by Paul Leavy; courtesy of *Valdosta Daily Times*.)

The Little Griffin Hospital had been closed since the late 1950s, but the old hospital building continued to stand until the late 1990s. This image shows the building as it appeared in April 1995. Shortly after this picture was taken, the structure was torn down to make way for a new building for Valdosta State University's Speech Language Pathology Department and the University Bookstore.

The Valdosta Symphony Orchestra was organized in 1990, further expanding opportunities to experience the arts in the city. The orchestra is composed of professional musicians from the region as well as students and faculty from Valdosta State University. Guest performers from around the world are a featured part of each season of the symphony's performances. (Courtesy of VSU Archives.)

The Brookwood Plaza shopping center had seen better days by the beginning of the 1990s, but it was soon taken over by Valdosta State University, which gave the facility a complete renovation. The building was designated the University Center and contains classrooms, meeting rooms, faculty and department offices, and a food court. (Courtesy of VSU Archives.)

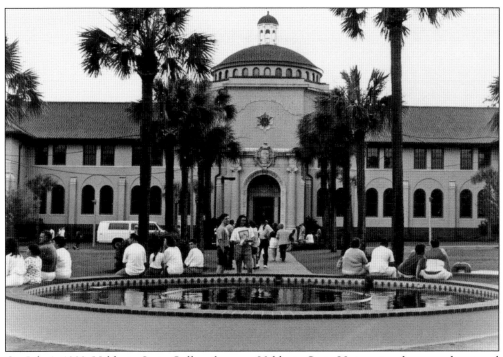

On July 1, 1993, Valdosta State College became Valdosta State University, the second regional university in the University System of Georgia. As part of its new mission to serve the professional graduate needs of the region, the school added doctoral programs and additional graduate degrees and increased its academic standards. The night before the change occurred, there was a large celebration on the front lawn of the campus. (Courtesy of VSU Archives.)

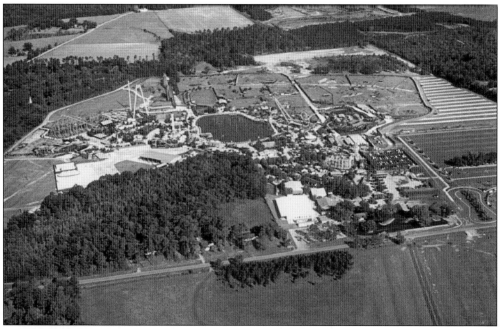

In 1996, Kent Buescher started the park that became Wild Adventures on a plot of farmland a few miles southwest of Valdosta. The park has grown substantially since its early days as a petting zoo. It currently features several roller coasters, exotic animals, shows, and a water park.

In the late 1990s, Valdosta lost two of its football giants. In 1996, Valdosta High School's longtime coach, Nick Hyder (right), passed away. His funeral was held at Cleveland Field to accommodate the number of fans who wanted to attend. In 1999, the original Valdosta High School coaching legend, Wright Bazemore (left), also passed away. The two legends combined for 21 state championships and five national titles during their nearly 50 years of service.

In 1998, the Valdosta Airport completed a new passenger terminal. The building it replaced is still standing and houses the airport's control tower. Currently, the airport offers three flights a day from Sunday through Friday and two on Saturday through Delta connector Atlantic Southeast Airlines. These flights all take passengers to Hartsfield-Jackson Atlanta International Airport.

In 2004, John J. Fretti became Valdosta's 43rd mayor. Since then, he has worked tirelessly to revitalize the downtown district, reduce substandard housing, increase opportunities for local small businesses, and improve the quality of life for the citizens of Valdosta. His efforts have also helped Valdosta earn numerous accolades, such as one of America's 100 Best Places to Live, a Preserve America Community, and ESPN's TitleTown USA. (Photograph by Wes Sewell.)

In 2004, Valdosta State University captured its first national football title. The Blazers defeated Pittsburgh State University 35-31 in the Division II NCAA National Championship. Since the first national championship, the Blazers won another national title in 2007 and have returned to the playoffs three times. (Courtesy of VSU Archives.)

After serving the needs of Valdosta High School for 81 years, Cleveland Field at Bazemore-Hyder Stadium underwent extensive renovations in 2004. Seating was expanded to 10,349, with plans for an additional 900 seats, and the original turf was removed and replaced with field turf. This image shows the renovations as the field is prepped for the installation of the field turf. (Courtesy of the Valdosta Touchdown Club.)

In 2004, the famous Viking Oak, located on St. Augustine Road, finally succumbed to old age, weather, and the environment. The tree had been struck by lightning in 1977, and local artist Joe Legge carved a 3,000-pound Viking statue from the part of the tree that fell. The statue is still on display Lowndes High School.

A long spell of dry weather created the perfect conditions for a series of wildfires to erupt in South Georgia near the Okefenokee Swamp in March 2007. Smoke from these wildfires blanketed the region, including Valdosta. This image shows the thick haze in downtown Valdosta. Normally, the courthouse would be visible in this image, but the smoke has completely obscured it. (Courtesy of Susan E. Davis.)

In 2008, Valdosta competed with 20 other towns to receive the honor of being named TitleTown USA by ESPN. In July 2008, it was announced that Valdosta had beaten out places like Boston, New York, and Los Angeles to earn the award. On July 28, 2008, ESPN sent reporter Wendi Nix and a camera crew to Valdosta to present the TitleTown trophy to the city. Thousands of Valdostans came to Bazemore-Hyder Stadium to show their support for Valdosta's many teams. Randall Godfrey and Jesse Tuggle, two former NFL players who played for Lowndes High School and Valdosta State College, attended the ceremony as well. The award serves as national recognition of the storied sporting tradition that has been well known in Valdosta for many years. In this image, Jesse Tuggle hoists the TitleTown USA trophy for the crowd to see just after Nix made the announcement.

BIBLIOGRAPHY

Davis, Deborah S. *Valdosta State University*. Charleston, SC: Arcadia, 2001.

General James Jackson Chapter, Daughters of the American Revolution. *History of Lowndes County, Georgia: 1825–1941*. Valdosta, GA: General James Jackson Chapter , Daughters of the American Revolution, 1994.

Schmier, Louis E. *Remembrance: Valdosta's Hebrew Congregation 1866–1986, 5626–5746*. Valdosta, GA. 1986.

———. *Valdosta and Lowndes County: A Ray in the Sunbelt*. Northridge, CA: Windsor Publications, 1988.

Shelton, Jane T. *Pines and Pioneers: A History of Lowndes County, Georgia 1825–1900*. Atlanta: Cherokee Publishing Company, 1976.

Tomberlin, Joseph A. *Lowndes County*. Charleston, SC: Arcadia, 2007.

www.arcadiapublishing.com

Discover books about the town where you grew up, the cities where your friends and families live, the town where your parents met, or even that retirement spot you've been dreaming about. Our Web site provides history lovers with exclusive deals, advanced notification about new titles, e-mail alerts of author events, and much more.

MADE IN THE

Arcadia Publishing, the leading local history publisher in the United States, is committed to making history accessible and meaningful through publishing books that celebrate and preserve the heritage of America's people and places. Consistent with our mission to preserve history on a local level, this book was printed in South Carolina on American-made paper and manufactured entirely in the United States.

This book carries the accredited Forest Stewardship Council (FSC) label and is printed on 100 percent FSC-certified paper. Products carrying the FSC label are independently certified to assure consumers that they come from forests that are managed to meet the social, economic, and ecological needs of present and future generations.

FSC
Mixed Sources
Product group from well-managed forests and other controlled sources

Cert no. SW-COC-001530
www.fsc.org
© 1996 Forest Stewardship Council

Find *Your* Place in History.